Wicked NASHVILLE

Wicked NASHVILLE

To Wayne, (continuing!:) Learning! Enjoy Nashville's history! about Elizabeth K. Goetsch

ELIZABETH K. GOETSCH

THE
History
PRESS

Published by The History Press
Charleston, SC
www.historypress.net

First published 2017

Manufactured in the United States

ISBN 9781625858313

Library of Congress Control Number: 2017938344

Notice: The information in this book is true and complete to the best of our knowledge. It is offered without guarantee on the part of the author or The History Press. The author and The History Press disclaim all liability in connection with the use of this book.

I dedicate this book to all of the "blasted flowers of the great stalk of humanity" who lived at some point in Nashville's history. I imagine you never thought your lives would be recognized in a book one day.

CONTENTS

FOREWORD

*I*n 2012, Elizabeth joined me in a new tour company called Echoes of Nashville Walking Tours, LLC. It was our goal to tell the untold stories of Nashville. We wanted people to know that Nashville has not only an unparalleled musical heritage, but also its true story was much deeper, richer and more diverse than most people realized. Elizabeth used her exceptional skill as a storyteller to grow Nashville's heritage tourism.

In many ways, Nashville stands at the crossroads of America, both literally in terms of its geography and figuratively by way of its impact on American culture. Many people have passed through or chose to live out their lives here. Most of those people and their stories are lost to history. Those more marginalized people tend to get forgotten, and the places they occupied leave us with few clues about their lives. For the past five years, Elizabeth has taken walks through these forgotten places, giving her a fresh perspective on the city and a deeper understanding of the people who once inhabited them. She saw the clues through the walking tours that led her to research these places and these people.

Elizabeth now merges that sense of place with exhaustive research methods and pulled some of these stories out of the forgotten recesses of the past. Through her talent as a storyteller, Elizabeth digs deeper into Nashville's often sordid past to bring us stories that may have never been told. By giving a voice to these people and retelling their stories, she requires the reader to consider larger questions that reverberate with us

today. What is crime? Who is the criminal? Where are they located? How does the place they inhabit factor into their lives? All of these questions remain relevant to us as we consider our own place in the city in which we live.

—JEFF SELLERS
Owner, Echoes of Nashville Walking Tours, LLC

ACKNOWLEDGEMENTS

\mathcal{T}he idea for this book started when I began working for Echoes of Nashville Walking Tours; I wanted to develop some tours that would garner attention, and a walking tour of Nashville's seedy past seemed promising. Without Jeff Sellers's invitation to help him manage the tour company, I would not be remotely aware of the complexities of Nashville's history. In my adventures of uncovering some of Nashville's more salacious past, I was reminded that this type of work needs a variety of help and encouragement. I am indebted to many people who assisted me with this book.

First, Candice Lawrence, my editor, made my first publishing experience as smooth as I can imagine it could be; thank you for reaching out in the first place to help me accomplish a major goal of mine. The quietest rock stars work in the Nashville Metro Archives, a treasure-trove of documents that tell Nashville's stories. I especially appreciate Sarah Arntz helping me with my last-minute photo fumble. Megan Spainhour at Tennessee State Library and Archives proved beyond patient with my photo requests.

I am indebted to those willing to listen to me verbalize thoughts about the stories I kept uncovering, oftentimes over a glass of whiskey. Dr. Angie Sirna listened and even stood ready with her portable scanner. Gilbert J. Backlund didn't stop asking questions, and that made me push myself further than I could have imagined. I remain envious that he got his picture taken with Skull Schulman. Eliza Garrity listened to any new Nashville story I shared with anticipation and excitement, providing me with motivation to keep

telling more stories. Stephanie Steinhorst patiently served as an anchor when I needed it most. And Brian Allison, who led the way and was as excited to tell stories about those otherwise forgotten in Nashville's history, thank you for indulging me over a fried bologna sandwich at Robert's.

Finally, my family has provided me a foundation that has allowed me to write without losing (all of) my mind. I would like to send shout-outs to my parental units and my grandparental units for their constant belief that I can do it (even if I don't know what I am doing). Ian, you never had any doubts that I would do anything else than succeed. And Allison and Will, you provided in ways that I will never be able to repay. I could not have done this without you.

INTRODUCTION

When asked, "What comes to mind when you think of Nashville?" most visitors respond "country music." Boots, cowboy hats, rhinestones and the twang of a steel guitar became synonymous with Music City, USA, in the late twentieth century. However, before music consumed Nashville's identity, the city's river access and wharf defined much of its character. Access to the river, railroads and intersecting overland roads gave people reasons to settle in the city. As the population increased, so did mischievous activities that often proved criminal. In 1865, a newspaper from Macon, Georgia, wrote, "I think that Nashville exhibits more inducement for drinking, gaming, prostitution and any other vice we know of, than any other city of its size and capacity on the continent."

Nashville's reputation as a rough and rowdy town existed early in its history. This status chagrined city leaders and moved them to promote a new nickname—the "Athens of the West"—in the 1830s. They wanted people to believe that Nashville was a city of prestige, culture and education. Those who arrived to the city by way of the wharfs stepped into a world of squalor and scandal. Smoky Row, a neighborhood surrounding the lower wharf, greeted newcomers with easy access to alcohol, drugs, gambling and prostitution. This reputation echoed beyond the banks of the Cumberland River, prompting the city leaders to advocate the new nickname. Efforts to reinforce the moniker and prestigious identity included building a new Greek Revival state capitol building. Regardless of city officials' work to remove the seedy places in town, Nashville's history reveals that vice could be available

to anybody for the right price. The places where alcohol flowed—both in times when it was legal and illegal—could be squashed in one place only to reappear in another. When the city removed the concentrated illegal happenings from one part of town, a new part of town would spring up with miscreants and criminal deeds.

In the earliest of Nashville's history, leaders attempted to regulate what they understood as the cause for wicked doings. Tennessee passed some of the first temperance laws of the new nation. Early punishments for criminal deeds included whippings, brandings and even hangings. Even with these potential consequences, not all citizens behaved according to the laws of their times. Different responses to illicit activities arose depending on the city's circumstances. In the case of prostitution during the American Civil War, the army seemingly could not fight it, so the officers legalized the act. Alcohol became illegal in the state of Tennessee from 1909 to 1938. However, the city of Nashville did not always abide by its own state's regulations, and liquor occasionally flowed more freely during the dry eras than it had in previous wet times.

This book weaves through Nashville's history with a focus on criminality and what that meant according to its era. Some historically punishment-inducing actions are all but common today. Yet some actions that took place in the past would be considered horrendous and wicked now. For Nashville, the city's rowdy character provided a place where churches grew as a means to combat immoral activities. One of Nashville's most famous church buildings, the Ryman Auditorium, began as a nondenominational church inspired by a fire-and-brimstone preacher speaking out against the evils of alcohol. While this book does not cover all of Nashville's rich history, it provides a little more background for some of the lesser-known happenings in this city.

1

FRONTIER NASHVILLE

\mathcal{W}ilderness once consumed middle Tennessee. Before people settled the city of Nashville, bison, bears and deer made up the majority of the population in the area. Native American tribes, including Shawnee, Chickasaw and Cherokee, used the area for hunting, migrating with the herds of animals. For the earliest groups of people who chose to settle the area, the land proved dangerous. Animals could, and did, kill. Native groups protecting their lands could, and did, kill. Even other settlers vying for resources became a threat. The early population that survived lived to share stories about these wild and sometimes wicked times.

One of the first white settlers to stay for any length of time was a Frenchman named Jacques-Timothe Boucher, Sieur de Montbrun. Simplifying his name, the English called him Timothy Demonbreun. Demonbreun found himself along the Cumberland River in the early 1770s. By 1775, he stayed for the summer in the area where Nashville stands today. He arrived in a boat with a few other men, and they set up a camp. Demonbreun chose that spot, for the "water was muddy, and that there must be a herd of buffalo not far off." He was correct. The geology along the river provided a salt lick—a deposit of salt and calcium that game could come and lick for nutrients. The bison came to the river for the water and the salt lick. This meant Demonbreun and his crew had easy access to game as they hunted over the summer. The Cumberland River, serving as a highway for early settlers, flows into the Mississippi River by way of the Ohio River. Demonbreun hunted on the Cumberland, traveled the river to the port at New Orleans (a French port,

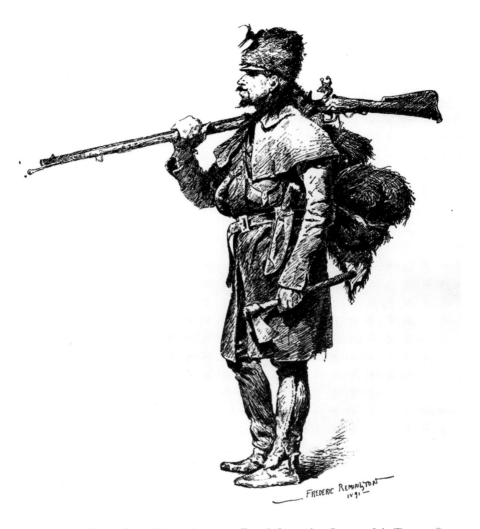

An artist's rendition of an eighteenth-century French fur trader. *Courtesy of the Tennessee State Library and Archives.*

where he spoke the language) and sold or traded the hides, tallow and furs that he and his men gathered during the summer.[1]

Demonbreun attempted hunting along other rivers, but did not find them as successful as the area around the salt lick along the Cumberland River. While residing in middle Tennessee, "many miles from any other white person," he "saw no Indians…but saw immense numbers of buffalo and other game." Even the distance from New Orleans did not deter him from

going back to the Cumberland River. During one of Demonbreun's treks to New Orleans, another hunting party found the Frenchman's hunting party and campsite. They called the place French Lick because of the French hunting camp located at the salt lick. "French Lick" and "Big Salt Lick" became interchangeable names for the site until "Nashville" was officially established in 1784.

On one of his trips back to Nashville in 1777, Demonbreun encountered another hunting party composed of six men and one woman. Demonbreun's recollections about this party demonstrated the dangers of hunting. A man in the hunting party, William Bowen, shot at an adult bison. Adult bison can grow to be upward of 1,400 pounds. He wounded the animal but did not kill it, so the mass of muscle and fur charged at him. Bowen turned to run but could not escape the charging bison through the surrounding thick terrain, so the bison trampled him. Given Bowen's severe injuries, the rest of his party did not discover the hapless hunter for nearly a week. Demonbreun remembered, "When found, he was nearly exhausted, and the parts bruised had mortified. He lay a victim to his sufferings another day, and thus expired." This hunting crew continued their hunting operations even among the potential danger of death.[2]

The rest of Bowen's crew told Demonbreun about another member in their party who did not survive the wilderness; however, it was the members

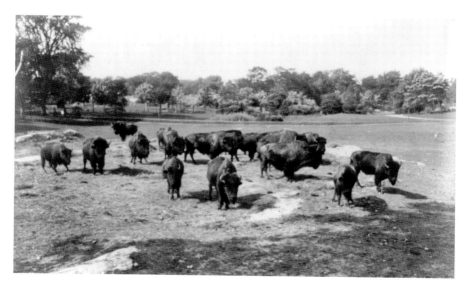

Bison and other large game attracted hunters to the land now occupied by the city of Nashville. *Library of Congress.*

of his party that contributed to his undoing. John "Big John" Duncan was married to the one woman of the group. One day, his wife became tired of Big John and decided to take up with another man in the party. She told the group that her husband was "a lazy man and a worthless hunter," and she was doing the work to support the two of them. Her lack of satisfaction drove her to another man, James Ferguson. Mrs. Duncan began bedding with Ferguson, "an agreeable, industrious young man, and the best hunter in the party." At one point, Big John got sick, so Mrs. Duncan convinced the group to just leave her ailing husband behind and continue along their journey. They complied with her urgings and left him behind. Big John Duncan died of hunger out in the Tennessee wilderness, in large part thanks to his heartless wife.

During the late 1700s, who owned, had rights to or could hunt on this land became controversial. Richard Henderson entered a treaty with some of the chiefs of the Cherokee Nation, but not all chiefs agreed to this land purchase. Also, the English government did not agree to this land exchange. By entering this agreement, Henderson violated an earlier proclamation by King George III, who wrote, "Great frauds and abuses have been committed in purchasing lands of the Indians. To prevent such irregularities, we strictly require that no private persons make any purchase of lands." The royal governor of North Carolina issued a statement: "This daring, unjust, and warrantable proceeding [Henderson's treaty] is most alarming and dangerous to the peace and welfare of this colony. If Henderson is suffered to proceed in this lawless undertaking, a settlement may be formed that will become an asylum to fugitives." Out on the frontier, who would enforce these land exchanges and proclamations? The Revolutionary War in the east called into question the idea of authority, so settlers questioned or outright disregarded proclamations regarding land transactions. In Nashville's earliest history, the vague nature of a sparsely populated area with no defined (or accepted) governing agency meant chaos sometimes ruled the land.[3]

In addition to chaos, Europeans who purchased land from land speculators, like Richard Henderson, didn't always settle at agreed locations. The settlers who purchased the land around French Lick from Richard Henderson did not settle on the purchased side of the Cumberland River. They settled on the side that the treaty granted to the Cherokee. Having their treaty broken and their lands settled by white families fueled natives' rebellion efforts. From the Wild West of French Lick and the surrounding area came report after report of raids and murders. Even as reports continued about families

getting killed, nonnative pioneers persisted in settling on the dangerous land with hopes that they could survive.

In 1779 and 1780, groups of people came out to settle Richard Henderson's land. The groups comprised all kinds of folk, including known murderers. Frederick Stump was a German who lived in Pennsylvania for a time. While there, he massacred ten natives. On a wintry January day in 1768, Stump told William Blyth that a few days prior six natives came to his house. He said they were drunk and disorderly and to make sure they did not kill him, Stump preemptively killed all six. He told Blyth that after he killed them, he dragged their bodies to a frozen creek, broke a hole in the ice and threw the bodies in the creek. Concerned that this murderous action might cause other natives to potentially retaliate, Stump traveled to surrounding areas to remove anybody who might report what he had done. He killed another native woman, two girls and one baby. He then burned their bodies in a nearby cabin. Governor Penn set out a reward of £200 for the apprehension of Frederick Stump for these heinous deeds. Stump used the opportunity of being a wanted man as a good excuse to leave Pennsylvania. After a short time in Florida, he eventually found himself with the John Donelson party traveling to the fort at French Lick. Within the first few months of their arrival, he became one of the original signers of the Cumberland Compact. Violence between white settlers and natives proved so commonplace that Stump's actions may not have even raised eyebrows among the new settlers.[4]

In 1780, seven new stations emerged along the Cumberland Settlement. As a means of establishing a local government, 250 men signed the Cumberland Compact. In this settlement's earliest form of government, twelve men were elected to the Tribunal of Notables. This elected panel heard about offenses committed, issued penalties and settled claims. This compact remained in effect until North Carolina established courts of equity in 1783. When North Carolina officially chartered the new town of Nashville in 1784, the government made provisions to establish a new courthouse and jail. Two hundred acres of land situated on the south side of the Cumberland River adjacent to the place called French Lick was divided into one-acre lots and sold. The land sale money was used to build a courthouse, jail, pillory and whipping post. The courthouse—an eighteen-foot by eighteen-foot hewn-log building—and the jail stood on the public square.[5]

These courts tried and punished crimes according to the local laws, oftentimes for deeds that are considered acceptable in modern society. In 1784, two women were tried for having a bastard, one man was tried for swearing in court and another man was tried for selling liquor. Among the

Rudimentary forts or stations developed throughout the Cumberland Settlement before the place became known as "Nashville." *From* The History of Nashville *by John Wooldridge.*

individuals listed on this 1784 court docket were Abednego Lewellan and Nancy Snow—they were charged with fornication. Tongues wagged prior to the charge about their relationship status. Nancy was originally married to a Nathan Turpin in Kentucky. They had three children together before Nathan passed away. She then married George Snow in 1781, before finding herself in middle Tennessee. Nancy had one child with George, and then he passed away. Sometime around 1784, rumors spread that she married her third husband, Abednego Lewellan. The clerk of the court shared with his wife that he had never issued a marriage license to Abednego and Nancy. The small population of the fort speculated that the two were "living in sin" or perhaps just married in secret. As one woman who lived at the French Lick fort said, admitting to a tendency to gossip, "There were very few of us in the fort, and we generally heard of everything that happened." Regardless of their relationship's legal status, Abednego and Nancy lived together.

After two years of living together, Abednego went on a hunting trip and was killed by some natives. Nancy lived alone at the fort for a short time before she moved in with a man named John Leeper. One of her neighbors, Nancy Gower Lucas, wrote later of a conversation she had with Nancy Snow-Lewellan. Nancy Lucas recounted that she asked the other Nancy if "she

was living with John Leeper in the same way she had lived with Abednego Lewellan. She said she was. Then I asked her if she had ever married Lewellan. She seemed very much hurt, and told me she had not." Social acceptance of cohabitation has changed over time, but in the eighteenth century, Nancy Turpin/Snow/Lewellan/Leeper lived in multiple situations that neighbors considered wicked.[6]

Another vice that motivated citizens to commit crimes flowed in a liquid form. A man by the name of John Boyd, or "King Boyd," established the first distillery—the Red Heifer—at the new settlement along the Cumberland River. He distilled raw corn whiskey at this primitive site. "The Red Heifer was a place of public and general resort; headquarters for news, depot for fresh meats, deer skins, bear skins, and buffalo robes—the mart and market of the bluff." It was a place where men "wet their whistles." When a new batch of the hot alcohol was ready, somebody at the distillery blew a horn. "At the sound of the horn, thirsty souls hastened to the Red Heifer." The Red Heifer resembled a modern bar, including regulars—patrons who were there so often that they became as much of a fixture as the bar itself. These early patrons drank from a buffalo horn that had been scraped clean; the bar stored each patron's horn by attaching them to the ceiling with a leather strap. These patrons did not always behave themselves in dignified manners.[7]

Trouble made itself known wherever liquor was served, and the Red Heifer certainly proved itself a happening place where problems arose. Fights broke out. Accusations of misdeeds spewed forth. In one case, John Boyd had left money on the bar and turned his back to fill up a customer's mug with the corn whiskey. When he turned around, the money was gone. Big King Boyd accused two of his patrons, Samuel Martin and Russell Gower, of taking it. Martin accused Boyd of malicious slander. Seeing so many problems arising

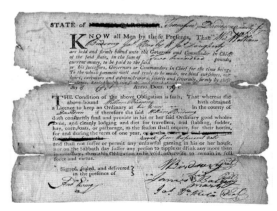

A tavern license issued by the State of Tennessee in 1796. *Courtesy of Nashville Metro Archives.*

from the liquid, local leader John Robertson decided to take action and forbade the distillation of corn in 1781.

Another tavern, called Black Bob's, opened soon after on Market Street (today's Second Avenue, a few blocks from the public square).[8] As the name suggests, the tavern owner was a man of color. Robert "Black Bob" Renfroe arrived in the Cumberland Settlement enslaved. As a quasi-independent slave, Robert Renfroe lived away from his owner and operated a fairly successful tavern. According to the Nashville slave codes, his operating a business as an enslaved person was illegal. However, wealthy white settlers tended to ignore the rules that proved inconvenient to them. The reputation of Black Bob's tavern was one of good times and well-behaved patrons; the manner in which he kept his bar attracted a variety of clientele and gave authorities no reason to close it. Bob was friendly and fair to everybody who came through. One of Bob's more famous, and frequent, patrons was a young lawyer by the name of Andrew Jackson.

In 1786 and 1787, two more taverns sprang up, including one opened by the fugitive, Frederick Stump. Stump was distilling as many as six hundred gallons of whiskey a year by 1795. As the demand for whiskey grew, so did the competition. With this surge of watering holes, Nashville began regulating the business of tippling. Even as other taverns closed or relocated, Bob's tavern received special treatment because of his business ethics. Black Bob's was run so well that the city established a special code for Robert Renfroe to maintain his tavern. The Territorial Assembly made a special note in a 1794 report, stating, "As to small local affairs, we find that 'Black Bob's Tavern' was yet *the* place in Nashville where the thirsty and hungry could resort and be satisfied. His was never a disorderly house. The Court, on motion, agree that [Bob] be permitted to sell *liquors and victuals* on his good behavior."[9] Before he died in 1822, Robert Renfroe successfully sued for his freedom.

When groups believed that the courts did not dispense justice according to their satisfaction, taking the law into their own hands seemed like a viable option. Mob law happened when groups gathered to enforce their own sense of justice, like in the case of George W. Welsh in 1809. For a few years, a band of men rode around the area between Nashville and the Kentucky border. They called themselves the Regulators. If they felt somebody was not served enough justice, the Regulators took it upon themselves to add to a citizen's sentence. They took the law into their own hands and used a variety of means to gather evidence. Once they captured a supposed criminal, they would whip, beat or hang him until near death to garner a confession. Sometime in 1805, George Welsh broke

into a store in Nashville. Captured and convicted, George fulfilled his legal obligation by being branded a thief by the city—a hot, iron brand seared the letter *T* on his cheek, literally branding him a thief. Then, in 1809, a string of livestock robberies happened in the areas north of Nashville. The Regulators brought George to a magistrate, who told them that there was not enough evidence against George to prosecute him in the courts. So they took George out to the woods to whip him and hang him as a means of getting a confession out of him. They wanted the names of a band of horse thieves that had been traveling through the area. He didn't know about the horse thieves, so could not confess. He did confess to being a deserter from the army. The Regulators took him out to the place where he said he deserted and shot him. Eventually, eight men identified as members of the Regulators were captured and prosecuted in the Kentucky courts.[10]

Sometimes the courts made a decision and the public did not like the outcome, prompting rogue justice beyond the walls of the courthouse. James Foster was charged with murdering his wife in 1835. He had asked her to go for a walk and then returned to his home alone. When her body was found, she was dead and had "marks of violence" on her body. The court quashed the charge on legal technicalities, and he was allowed to walk as a free man. As word got out that Foster would be set free, several hundred people gathered outside the courthouse. Foster saw the vitriol of the crowd and asked for protection. His lawyer said he would do the best he could to escort Foster to safety. As the two men began to venture into the crowd, fear overtook Foster and he used what he perceived as his only defense: his feet. He attempted to flee, but the crowd caught him and took him to a field just on the outskirts of town. First, they flogged him with 150 lashes, and then they tarred and feathered him. The mob marched Foster back through the streets of Nashville to display how the angry crowd felt about him. A reporter who had seen Foster just an hour prior to the march commented, "we could scarcely recognize he was a *Man*. The mob believed *that he was a monster* at heart, and were determined that his external appearance should correspond to the inner man."[11] Foster perished under the many hands of an unaccountable group of people. Not everybody agreed with the mob's doings. The reporter voiced his opinions at the end of the article, indicating that humans weren't the only ones who would dispense justice: "Perhaps, this is as strong a case as could be presented; but we are believers in the supremacy of the law; those whom the law condemns should be punished, and those the law fails to punish should be left to the punishment of a higher court."

Even within the courts, officials didn't always stay out of trouble. Future president Andrew Jackson was nominated as Nashville's prosecuting attorney in 1788. In that year he met his future wife, Rachel Donelson Robards. Rachel, the daughter of Nashville's leader John Donelson, married Lewis Robards in 1785. According to many sources, Robards abused his wife. One boarder recalled, "[Lewis's] conduct toward her was cruel and unmanly in the extreme.…He was in the habit of leaving his wife's bed, and spending the night with negro women." Another boarder reported the Robards lived unhappily, and "the uneasiness continued to increase." In 1788, Lewis wrote to Rachel's mother, asking Mrs. Donelson to take her daughter back, "as he did not intend to live with her any longer." When Rachel returned home, she met another boarder at her mother's residence: Andrew Jackson. Lewis Robards attempted to move to Nashville to live with his wife at Mrs. Donelson's residence. While there, his behavior changed little, and his jealousy caused him to have an argument with Jackson. Andrew Jackson removed himself from his living situation at the Donelson residence to lessen any further tensions. His marriage strained yet again, Lewis Robards stayed in Nashville for a few months before heading to Kentucky. Rachel Donelson Robards decided to go to Natchez, in what was then the French colonial territory of Mississippi.

There is no evidence that Lewis Robards filed for divorce during this separation period, but Rachel believed he had done so. Rachel's plan included traveling to Natchez with Colonel Robert Stark, "a highly esteemed old man." Andrew Jackson told Colonel Stark that he would escort the Stark party as a protector. This journey included eight boats and nearly forty people. During this journey, a member of the party reported seeing Rachel and Andrew "bedding together in the wilderness as man and wife." They married in Natchez in 1789. The process of a divorce was rare, and it would have been difficult to prove; additionally, the various government entities involved in the areas where Rachel traveled would have complicated the matter. This potential bigamy, and Rachel's honor, resurfaced during Andrew Jackson's campaign for the presidency. Tongues wagged about the potential immorality practiced by a future president. Lewis Robards finally finished the legal process of divorce in 1793, and the Jacksons remarried legally in 1794.[12]

Even though Rachel Robards Jackson traveled in parties and with men who were there to protect her, journeys of any kind held great risk. Trekking over land often proved dangerous, even lethal, for travelers in the late eighteenth and early nineteenth centuries. Andrew Jackson's own urge to

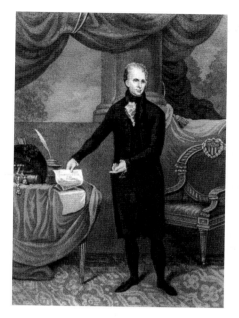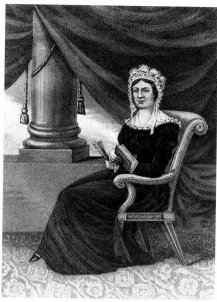

Left: Prior to becoming president, Andrew Jackson served as a lawyer in Nashville. *Library of Congress*.

Right: Rachel Donelson Jackson met Andrew Jackson when he was a boarder at his mother's house. *Library of Congress*.

travel with Rachel's group as a means of being additional protection was not unprecedented. Robberies and murders happened. While many stories claimed this was violence committed by natives, it became evident over time that unscrupulous characters chose these routes to target vulnerable travelers. Nashville's fairly isolated location in middle Tennessee served as an ideal site for criminals to commit their felonious deeds.

In 1814, a report of a roadside murder surfaced not too far from Nashville. Parts of a woman's body were found; the body had been mangled and then eaten by hogs. The only traces of her identity came from a pair of stockings with the initials "S.W" embroidered at the top. Shoes and socks with corduroy soles were found with the body parts, items that only a woman of wealth would have owned. In addition to her chic garb, the report made note that she had "an elegant set of teeth." In life, this woman was clearly well-to-do. Those who discovered her body speculated that she must have been traveling with her husband. Further speculation concluded that her husband was also murdered and hidden somewhere nearby; the region's

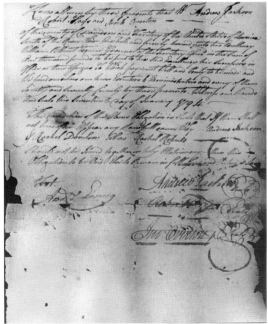

Above: As Andrew Jackson campaigned for the presidency, the "scandal" of bigamy became an issue his opponents used against him. *Courtesy of Nashville Metro Archives.*

Left: A copy of the Jacksons' legitimate marriage license from 1794. *Courtesy of Nashville Metro Archives.*

karst topography meant abundant caves and sinkholes to hide bodies. Nobody suggested publically that maybe her husband did the awful deed and left her to the wild animals. No other clues surfaced, her husband was never found and the uncovered woman remained unknown.

The wilderness surrounding Nashville provided shelter for roadside villains. While barbarous murder served as a warning to travelers about the dangers on the road, travelers were more likely to fall victim to robberies. In 1817, a notorious mail thief named Joseph Thompson Hare was finally caught and sentenced for his crimes. Before he died, he published a book-length confession. In the years following his publication, his testimony became evidence for early criminal researchers. What motivated men to commit crimes?

For years in the early 1800s, Hare roamed roads and wildernesses, seeking susceptible travelers to rob. In some cases, he traveled alone. In most cases, he traveled with an unscrupulous band; it proved easier to overtake vulnerable travelers with a group of robbers. He reported living throughout the many caves of the Tennessee wilderness. One of his first successful robberies took place on a road that led to Nashville. His thieving band found a group of four men and their horses. Joseph directed his compatriots to overtake these travelers but not harm them. The gang captured the travelers and held them. Hare threatened the four men; the first one to make a move "would be blown to hell." The thieves

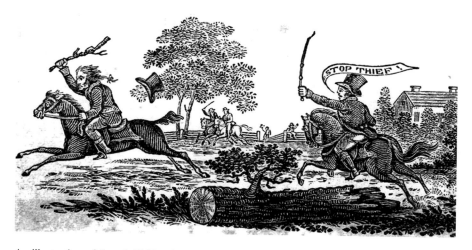

An illustration of Joseph T. Hare's exploits as a bandit. *From an 1844 publication of* The Life of the Celebrated Mail Robber and Daring Highwayman, Joseph Thompson Hare Who Committed Depredations in the Cities of New York and Philadelphia to the Amount of Nearly Ninety Thousand Dollars.

took the men's horses and supplies and then released the travelers to flee on foot. Joseph T. Hare passed through Nashville multiple times as he gallivanted across the country, living his thieving lifestyle. Over the course of his pilfering career, Joseph T. Hare estimated he stole over $90,000 from travelers. In today's currency, that equates to about $1.6 million. He eventually got caught and went to trial. Hare admitted to wrongdoing and publically apologized. The Philadelphia judge who sentenced Hare to death by hanging further chastised him by saying "there could be no apology for any person to forsake an honest employment to follow one replete with vice and crime."[13] While waiting for his execution "confined in a dreary dungeon, heavily ironed," he wrote a memoir as a means to warn others about a life of sin. "I hope that it may serve as a caution to other persons....May the God of mercy pardon and receive my soul."[14] Hare's exploits remained a popular case study of criminal minds throughout the nineteenth century.[15]

All sorts of sins arrived in Nashville with the earliest settlers. As the city grew, so did the temptations and, ultimately, criminal activity. In the first half of the nineteenth century and beyond, Nashville's authorities needed to figure out how to control and eradicate the immoral deeds that continued in the city.

2

Who Would Envy the Night Watch?

As Nashville developed into a thriving port city, the population grew. With the growing population came more misdeeds and the need to regulate these mischievous happenings. In 1806, with Nashville's incorporation came the right for the city to enforce laws as its leaders saw fit. Initial efforts included electing a sheriff and town constable to collect taxes and enforce laws. The populace also elected a recorder to track the licenses issued, document the taxes collected and record the general happenings of the city. The city government often dictated what was considered wicked, and the police enforced these regulations.

Soon after the initial creation of a sheriff and constable, the city council formed the Day Police "to see that the laws of this State and of this City are enforced."[16] As the name suggests, the Day Police commenced "the discharge of their duties at sunrise in the morning and continue[d] the same until sunset in the evening."[17] However, not all illegal happenings took place in the daylight. By the 1830s, the city had established the Night Watch as a group of officials who assisted with law enforcement during the evening hours. These men monitored misbehaviors and took people to jail for criminal acts. By 1848, the city had set up a workhouse as form of punishment for those unable to pay their fines.

Nashville's population, especially those denizens of Smoky Row, provided plenty of work for the watchmen. Officers found that it did not matter what time of day they worked, as citizens were capable of making trouble during all hours. One newspaper editor wrote about the dangers for those working

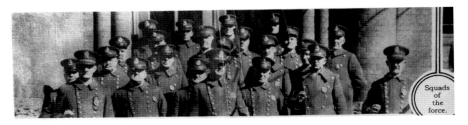

The Nashville Police Force, circa 1920. *Courtesy of Nashville Metro Archives.*

in law enforcement: "The duties of the night-watch are of the most laborious nature always, and frequently of the most dangerous. Forced to come in contact with drunken maniacs, professed throat-cutters, house-breakers, fugitives, and all sorts of evil-doers, he is at any moment liable to have…his underpinning knocked out. Who would envy the night watch?"

Fifteen men made up the first assigned Night Watch in the early 1850s. Initially, the Night Watch only worked during the time of day their name suggested—night. Officers worked from sunset to sunrise, monitoring citizens' behaviors and enforcing local regulations. By 1857, the Nashville City Council had voted to convert the watches into an official police department, combining officers of both watches. In that same measure, they voted to expand the force to twenty-four individuals and raise the pay for police officers to two dollars a day.[18] The city was growing, after all.

The officers involved in law enforcement in the 1850s did not have to seek out people breaking local regulations; certain citizens of Nashville were very capable of causing trouble all on their own. Particular areas of town attracted residents who were more likely to find themselves mired in mischief, especially close to the wharfs along the Cumberland River. The area called Smoky Row garnered a lot of attention. The more attention it drew, the more citizens in Nashville called for better enforcement of regulations. This proved a double-edged sword, as arrests increased with the number of officers. This did not necessarily demonstrate a rise in crime, but it did create a rise in awareness, and the city continued to push for better restrictions against the items and industries that caused criminal activities.

Nashville newspapers played a role in how the citizens perceived what was happening in their city, especially relating to potential criminal activity. As a city that was home to dozens of publishing houses and several newspaper printers, circulation competition was fierce. One way to increase newspaper sales came in the form of sensationalizing—stories with especially juicy

details sold copies. Another way newspapers drove sales was providing specific access to information. In the case of the *Nashville Banner*, the publishers offered a sneak peek into Nashville's rowdy crowd with a regular editorial called "Police Court." The editor not only shared with his readers the misdeeds of citizens making an appearance at court but also did so with wit and snark. Still, certain tactics implemented by newspapers drew ire from competition. Sensationalizing stories may have sold copies, but it made it difficult for readers to know if what they were reading was true. It also provided fodder for competing newspapers to call out falsehoods of other papers and proclaim that their copy was the best copy.

Because of the political alignments of some newspapers, content published often had an agenda. The police department sometimes found itself at the center of these journalistic tiffs. And certain activities considered immoral or detrimental to society could also be used as tools to sell more copies. Citizens who agreed with a specific viewpoint bought more newspapers that promoted those agendas, so the newspapers would continue to promote those particular viewpoints. When newspapers stressed that criminal activity was on the rise, the community supported an increase in police efforts. City authorities sometimes responded to these public outcries and raised the level of enforcement by increasing officers.

Having law enforcement, specifically officers assigned as detectives, may be something taken for granted today, but in the early nineteenth century, unsolved crimes usually stayed that way—unresolved. Michael Hoover and William Pryor were murdered in 1833, but their deaths remain a mystery. Early on a March morning in 1833, a servant of a local boardinghouse went into Hoover and Pryor's room to make a fire. The servant turned from the fireplace to realize the state of the bodies in the bed. He discovered Hoover and Pryor lying there with their heads beaten. Not quite dead, the two men clung to life. Pryor rested on the bed entirely senseless, while Hoover attempted to speak. The servant called the boardinghouse keeper to the room; he then sent for the sheriff. The beaten men remained incoherent for the remaining hours of their lives before they perished. Who could have done this horrific deed?

News about the brutal murder traveled quickly throughout Nashville and the surrounding area. The initial theory that surfaced speculated that the men quarreled with each other verbally before getting into a fistfight. The extent of their injuries, however, suggested that neither one could sustain retaliating in a way that would have caused the other man's wounds. With no official detectives and criminal investigation techniques practically

nonexistent, the sheriff reacted to the crime by arresting any potential witnesses. According to the servant, the two men arrived to the house late the night before after an evening filled with drinking and gambling. The best theory the sheriff could come up with was that somebody lost money to these gentlemen, followed them home and "struck the fatal blows."[19] A young man named Thomas Hill was arrested for the crime, but he escaped. That proved the end of the investigation. No further arrests were made. The courts could not prosecute anybody for the crime. Who killed these men and for what reason remain mysteries.

The idea of investigative work proved a novel one even into the 1870s and 1880s. It was not until the later part of the nineteenth century that newspapers started to promote the idea that "modern crime has become a science."[20] For some Victorian sensibilities, the idea of criminal investigation seemed vile—detectives had to ask inappropriate questions and tentatively reveal unsavory character traits. Nashville city leadership did not see the value of detectives and, at one point, even tried to outlaw private detective practice. Detectives remained separate from the Nashville Police Department until 1883, when the city council voted to open positions specifically for detective officers. Prior to that point, and for a time afterward, private

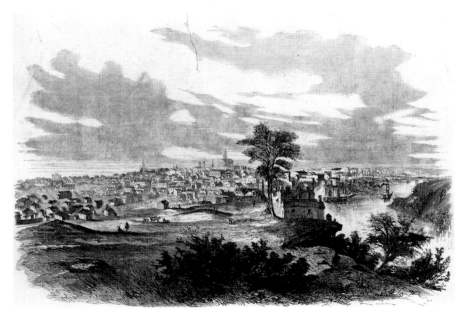

Nashville had three wharfs along the banks of the Cumberland River throughout the mid- and late nineteenth century. *Courtesy of Nashville Metro Archives.*

detectives worked independently of the police department, often providing assistance with investigative work. Newspapers did not help the reputation of detectives, as reporters sometimes painted detectives as being in cahoots with the criminals. In the 1890s, when the Pinkerton Detective Agency out of Chicago gained a reputation of being a force of thugs, Nashville's reporters sometimes mixed identities of Pinkerton detectives and local detectives. The Pinkerton Detective Agency evolved into a nationwide agency that contracted its detectives to assist companies with investigating crimes. During this time, however, companies often hired the agency to break up or discourage labor disputes. This reputation carried over into what citizens believed regular detectives did from day to day. The confusion did not help with the reputation of detectives in the city of Nashville.

Within city limits, neighborhoods bled into one another without distinct definitions. Police officers often lived in the same neighborhoods where they worked, among those they charged with crimes. Smoky Row served as one of these complex places comprising a mix of citizens. A swath between wards two and four in Nashville garnered a reputation as those blocks evolved as ones containing the bawdiest of bawdy houses and rowdiest of rowdy bars. However, not all citizens who lived and worked among the brothels and tippling houses partook in the nefarious activities of their neighbors. The 1860 federal census reveals that Sebastian Barth was a forty-four-year-old Methodist clergyman who lived with his wife and seven children in a home sandwiched between a tippling house where four prostitutes lived and a private home owned by prostitutes. They all likely purchased their groceries from the same merchant. Samuel Starkie worked for the city police. He lived in the Second Ward with his wife and five children. His house stood three doors down from Sallie Jacob, a twenty-four-year-old prostitute. She lived next door to Mary Crieger, a twenty-three-year-old prostitute who had a four-year-old girl. In 1860, Starkie's youngest child was a four-year-old boy. Undoubtedly, in this neighborhood, a child of a prostitute and a child of a police officer played together in the streets. Carpenters, laborers and merchants lived among prostitutes and barkeeps. And they lived just blocks away from where the state capitol building was being constructed.

Combating the vice and combating the *reputation* of vice were separate efforts, especially as the city vied to maintain its status as the state capital of Tennessee. It served as the state capital from 1812 through 1817. The capital city of Tennessee had moved around to a total of five other cities and finally settled back in Nashville beginning in 1826. Nashvillians had plenty of motivation to maintain a proper, prestigious city. Another measure

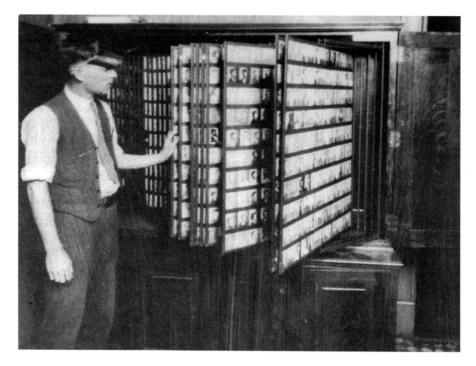

A collection of criminal mugshots Nashville police used for reference in the early twentieth century. *Courtesy of Nashville Metro Archives.*

to compete with the rough-and-tumble feel of Nashville's more scandalous neighborhoods came by way of an early public relations effort. Nashville elite attempted to give the city a new identity, starting with branding the city as prestigious. The Athens of the West was meant to elevate the city's status in the eyes of citizens from elsewhere. Athens, Greece, once served as the foundation to early democracy and Western traditions. Nashville wanted its own identity to represent something beyond its then identity of a port city. The city's authorities reinforced this self-nominated sobriquet by designing and building its state capitol building fully in the Greek Revival tradition. City officials pushed for the use of this idea even as the city was hosting the Tennessee Centennial Exhibition in 1897. Again, as a means to emphasize the city's nickname, exposition planners decided to incorporate Greek imagery throughout the park. A full-size replica of the Parthenon stood in the center of the expansive fairgrounds. Even with the efforts of the city elite to change Nashville's notoriety, vice still ran rampant through this Athens of the West.

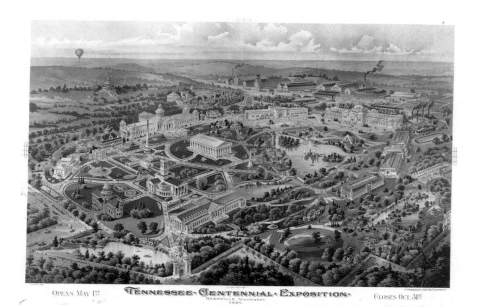

OPENS MAY 1ST · TENNESSEE · CENTENNIAL · EXPOSITION · CLOSES OCT. 31ST
NASHVILLE, TENNESSEE.
1897.

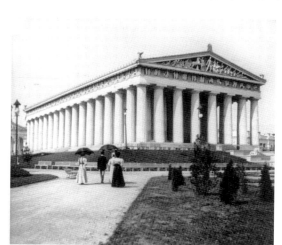

Above: Nashville hosted the Tennessee Centennial Exposition in 1897. *Library of Congress.*

Left: A full-size scale replica of the Parthenon stood at the center of the Tennessee Centennial Exposition. *Courtesy of Nashville Metro Archives.*

Morality sometimes made exceptions, especially for money. During the Tennessee Centennial Exposition in 1897, Nashville authorities thought it best to lessen the restrictions and enforcement on gaming and saloons. With expected out-of-towners, the city did not want to diminish the excitement of those planning to visit. Additionally, these vices proved to be great income generators for business owners and the city, as well as a draw for some out-of-town visitors. A report on the exposition's business influence came out in

June 1897: "Within a radius of five or six squares [downtown Nashville], the general consensus of opinion of all merchants is a noticeable improvement, which can be traced to the Centennial....The Maxwell, Utopia, and Tulane hotels are doing a great amount of business, and particularly in the saloon and cigar departments."[21]

Official police worked in the city during the exposition, and a special force was created specifically for ensuring the crowds' safety during the event. Anticipating throngs of people to visit the fairgrounds during the six-month exposition, the city allowed the Tennessee Centennial Exposition fairgrounds to be incorporated. This allowed a separate functioning government within the fairgrounds that included a separate police force called the Centennial Guard. The incorporation of Centennial City was set to expire on January 1, 1898—it existed long enough to monitor the exposition in 1897. To ensure no bad behavior took place, specific restrictions were outlined in the ordinances laid out by the new Centennial City. These included prohibiting "indecent exhibitions," regulating and prohibiting gambling and punishing "breaches of good order committed within its jurisdiction."[22] Nearly two million people visited the fairgrounds over the six-month period, and the city prided itself on the minimal criminal activity that took place during its celebration.

THE JUNGLES OF SMOKY ROW

*S*winging doors did not always signify saloons, and red lights did not glow in front of brothels, but drinking and prostitution existed in Nashville from the time the city was established. Mid-nineteenth-century Nashville maps display an orderly grids of roads, with a concentration of brick buildings and wooden structures extending from the riverfront. Few of these maps convey the rise and fall of the undulating landscape. Many maps show legal businesses and identify prominent residences; however, none of these pastel-hued documents show the character of the city or the personalities who maneuvered throughout the streets and buildings daily. An area identified as Smoky Row started at the riverfront's wharfs and covered the ground to Summer Street (today Fifth Avenue). In the other direction, it existed roughly from Jackson Street to Cedar Street (today Charlotte Avenue).[23] At first glance, the streets may not piqué interest, but within that area outlined on a map existed an infamous neighborhood that both local citizens and visitors from out of town knew. Brothels and houses of ill-fame made up the brick structures, wood cabins, shacks and lean-tos of Smoky Row. Criddle Street served as a center for some of the most active houses of ill-repute, at the heart of Smoky Row. These dens of sin stood among boardinghouses, grocery stores, family residences and even churches. Regular citizens lived and worked in this neighborhood filled with vice.

For many of the businesses, the misdeeds happened "back of house" or in an underhanded manner. Getting caught for illegal happenings meant getting fined by the court. When citizens could not pay the fines, they were

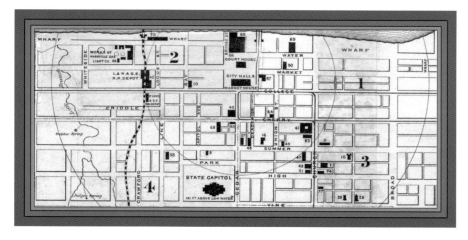

This 1880 map shows the approximate area of the Smoky Row neighborhoods. The large numbers indicate the wards. *Courtesy of Nashville Metro Archives.*

required to spend time doing hard labor in the workhouse by breaking rocks. If the criminal's deed proved too severe, the offender would spend time in the penitentiary. Even with these penalties potentially looming if caught, some citizens found the temptations to break the law too great.

One of the more well-known denizens of "the jungles of Smoky" was Jack Cunningham, "whose name is a tower of strength to inequity, and whose record is more consistent in its unmitigated depravity, if possible than that of his cloven-footed master." Jack Cunningham legally owned a grocery store in Smoky Row but illegally ran Smoky Row. Jack managed the section of Smoky Row called Cunningham's Exchange, and local folks called him "King of Smoky." With all of his devious doings, Jack frequently made appearances at the criminal court in Nashville. Lighter offenses included getting drunk, gambling and tippling without a license. Heavier crimes included beating, stabbing and other physical abuses. During one mêlée at his bar, Jack picked "a belligerent female up in his arms from the floor, where she had been laid out, and throwing her, like a bundle of straw, out on the pavement." He was fined twelve dollars for this misdeed. In another one of his fits, Jack beat a handicapped homeless man with the man's cane. For that offense, he was fined eight dollars. His criminal work allowed him to afford many of his misdeeds.[24]

Men were not the only ones who participated in criminal activities in Smoky Row. Due to the contemporary understanding of the "fairer nature" inherently found among females, women committing crimes attracted more

attention. Among these scandalous broads in Nashville, some women rose in power as female rulers of the reprobate. Born in 1821 and raised in the world of brothels and taverns, Parmelia Street became a keeper of a house of ill-repute. During her reign, she became Jack Cunningham's mistress, "Queen of Smoky." Jack affectionately called her "Meely." Locals called her "Parmelia Street of the Street, Streety," as a nickname intended to play on her work as a prostitute. Like Jack, she found herself in front of a criminal court judge quite often. In more than one case, Parmelia did not show up for court. The court just assigned her a fine, anyway, as she had been in front of the court so many times before. While she preferred to pay her fines, she also broke her fair share of rocks "contribut[ing] her share towards repairing the public highway."[25] In another case, both Jack and Parmelia were due in court. They wrote a letter, instead:

mr rine I Cannot Come to trile this morning I am sick to morere morning I will bee redy. Permealy street.

Mr. Watson an Mr. rine I am Ready when mealy gits rite. Jack Cunningham."

[Translation: Mr. Rine, I cannot come to trial this morning. I am sick. Tomorrow morning, I will be ready. Permealy Street. Mr. Watson and Mr. Rine, I am ready when Mealy gets right. Jack Cunningham.]

The delay in trial was granted for Jack and Parmelia. A local newspaper expressed hope that these two would run away together instead of returning to court. However, they stayed and faced their consequences.[26]

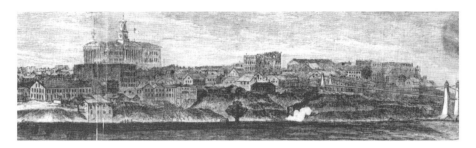

The area to the right of the railroad bridge hosted the neighborhood called Smoky Row. *Courtesy of Nashville Metro Archives.*

Whether it was the clash of their strong personalities or their mutual love of booze, Parmelia Street and Jack Cunningham did not always stay affectionate or faithful to each other. Legal documents don't reveal what kind of relationship arrangement the two had, but in the summer of 1857, Jack began getting especially cozy with Mary Alley, a twenty-one-year-old prostitute who worked in a nearby tippling house. Maybe Jack and Parmelia agreed on their split, or maybe Parmelia felt Jack betrayed her by choosing a new woman twenty years Parmelia's junior. Whatever happened, during an argument on a sweltering July day, Jack Cunningham knocked down his "patron saint and fast friend, Parmelia." He paid his fine and thought that might have been the end of the situation with Parmelia Street.

Parmelia did not forget what Jack did to her. Within a few weeks, she reported to the police that Jack Cunningham and Mary Alley had committed a robbery. As she had been in cahoots with Jack before, this was not the first time that Parmelia had this sort of information about Jack's criminal acts. Her wounds, both physical and emotional, bled in ways that forced her to turn in her former lover (and, of course, her former lover's new bedmate). Jack and Mary went to trial. Mary was acquitted. Jack was sentenced to the penitentiary for six years. His position in Smoky Row did not stay vacant for long. A new unscrupulous character took his place. Richard Finn, "a distinguished individual of a dubious character," filled Jack's now vacant position, even managing Jack's Cunningham's Exchange.[27] Not to be outdone, Richard followed Jack's lead and found himself in front of a judge often for his own proclivity toward misbehaving.

Madam Parmelia Street continued to work as a bagnio keeper or what polite society referred to as a "private boardinghouse keeper." In 1860, a visitor from Missouri patronized Parmelia Street's brothel and had one hundred dollars in gold coins stolen from him. According to his police report, as "Missouri" woke up in his rented room, a known miscreant named Bill Ray was hovering over him like "a guardian angel" while rummaging through the Missourian's coat. As Missouri woke from his dreamlike state, where he was possibly drugged to sleep, he realized he had been robbed. The police took the report and arrested Bill Ray and Parmelia Street. The police believed Parmelia stole the money and Bill Ray was only there to follow and remove from Missouri's possessions anything that Parmelia missed. As with other illegal acts for which Parmelia got caught, she paid her fine and continued living in Smoky Row.[28]

Parmelia made a name for herself, but she was not the only working woman in Smoky Row. A number of women owned tippling houses, and

hundreds of women worked as prostitutes. Several women made regular appearances at criminal court in Nashville. The most common reasons women would find themselves in front of a judge were either for creating a disturbance or public drunkenness. In the case of two known prostitutes, Lucy Nugent and Huldy Johnson, brought before the judge for being drunk and disorderly, a third and fourth witness were present to describe what they saw when the ladies were arrested. The witnesses described seventeen-year-old Lucy Nugent's actions: "She wasn't what you might say drunk, though she had a little [alcohol] in her—just enough to make her funny." The judge released Lucy. For sixteen-year-old Huldy Johnson, the same witness said she "didn't see [Huldy] do nuthin except put Lucy to bed."[29] The judge set young Huldy free, too.

Being rowdy or loud often got these working ladies in trouble. "Emeline Hooper, another blasted flower from the great stalk of humanity, was arrested for disorderly conduct. The evidence proved that Emeline is a whoop-er by nature as well as by name, and that she was disposed to interfere materially with the peace and dignity of the commonwealth with her 'whoop-de-doo-den-doo.'"[30] In the case of Mary Littrel, "her tongue became ingovernable, and her locomotive powers laughed at her impotent will. Her gyrations attracted public attention, and the result was her incarceration."[31] Frances Webb was "an old offender, and no amount of punishment will correct her misdeeds. When the spirits move her, they generally move her against the laws." These women were familiar with being brought before a judge. This was life for many citizens of Smoky Row.

Tina Claxton's frequent, unintentional visits at court demonstrated her penchant for publically acting wild. A daughter of a prostitute, Tina Claxton was called a "heroine of the shades of Smoky and Lieutenant General of Jack [Cunningham]." She found herself in trouble often during her late teens and early twenties. As one newspaper reported, "Tina Claxton is one of the most troublesome feminines [sic] in the list of delinquents who figure in the municipal records of the country. Tina is a law-abiding citizen, when she is duly sober."[32] According to that same newspaper, sober was not a state Tina stayed in for very long. One wintry day, Parmelia Street got into an argument with Tina's mother, another prostitute of Smoky Row. The argument quickly turned physical, and Tina began attacking Parmelia on behalf of her mother, Susan Claxton. Tina picked up a rock and swung toward Parmelia; the rock made contact with Parmelia's head. As a crowd gathered, Parmelia's mother joined in to assist her daughter. At least two more working girls joined the mêlée that spilled out into the street. The

women were rolling in the "slough of the streets" when they were arrested and brought before the court. The whole party was sent down to the workhouse to break rocks.[33]

When she was in her early twenties, Tina Claxton married a Mexican War veteran named William Nuthill. A large crowd gathered to witness their nuptials; this well-known prostitute was about to settle down. Not much is known of William Nuthill's background, but it appears his sister also worked as a prostitute and he was raised in the same world as Tina. William and Tina seemed initially happy as husband and wife. But in the neighborhood of Smoky, gossip spread quickly. One editorial summed up what neighbors had been saying: "The knot matrimonial did not prove a Gordian knot to the Nuthill's, and they have lived unconscious of its binding effect." They would occasionally become intimate and then find themselves apart again. At one point their relationship style proved too much for William. In a fit of jealousy, William swung at Tina, punched her in the eye and knocked her to the ground. Tina got up and began fighting back. After they were separated and arrested, the two were fined. Tina paid her fine, but William had to go break rocks for eleven days.[34]

Much to the chagrin of proper Nashville citizens, the city played host to several bawdy houses of varying levels of class. While most prostitutes worked in slum-like conditions, there were a few upper-class working women who owned real estate and property. The 1860 federal census of Nashville's population listed 207 women as either "prostitute" or "keeper of house of ill fame"; of those women, 27 had real estate or valuable personal property to their names. The number of prostitutes working is likely higher than what the census indicated. Women in the nineteenth century commonly used occupations like laundress, ironer or seamstress, as common euphemisms for "prostitute" in censuses. Additionally, some women may not have officially used their own bodies for the industry; rather, they owned the tavern or business building that housed the prostitutes. Nashville's census serves as a rare gem that specifically lists prostitutes and bagnio keepers. This allows historians an opportunity to get a better sense about life for some of these women.

Prostitution looked different depending on class, skin color and even freedom. Many women working in the industry had little to their names except the clothes they wore. They worked in tiny, dank rooms called "cribs." The concentration of brothels stood on Criddle Street in the 1850s. Criddle Street's reputation carried enough weight that reporters sometimes referred to the prostitutes as members of the "Criddle Street Society" and

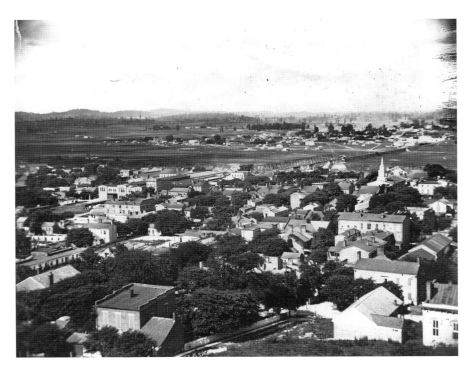

This circa 1880s view of Nashville from the capitol building looking east shows a portion of the neighborhood known as Smoky Row. *Courtesy of the Tennessee State Library and Archives.*

expected the readers to understand that meant they worked in the brothels. In a port city like Nashville, with an abundance of male workers from the docks and ships, some women would service dozens of men a day with very little pay. Other women made the industry work for them, gaining financial independence; however, even that could be at the cost of another person's life. Before the American Civil War, several women listed as prostitutes in Nashville also owned enslaved African women. Having a slave who could also work in the sex trade provided an additional source of income. Freedom for some women meant slavery for others.

Modern lore paints an image of nineteenth-century prostitutes in colorful petticoats revealing fishnet stockings and feather boas draped over tight corsets, but the reality of the sex trade meant the vast majority of women worked in cribs. The cribs where the women worked were small, dirty, dank and with little glamour. Most prostitutes lived in poverty, far from the glamorous lifestyle often associated with the misunderstandings of

nineteenth-century prostitution. Access to proper medical assistance was out of reach for most of these women, so treatment for sexually transmitted diseases often meant seeking out a charlatan who ran advertisements for medicines in the newspaper. Unwanted pregnancies proved yet another hazard for women working in the trade. For many prostitutes, these risks meant a shorter life expectancy. In the nineteenth century, few prospects existed for women to work or live independently of men; prostitution, even with its dangers, served as one opportunity to do so.

For some women, life presented a situation in which they had little choice but to turn to prostitution. One woman from Chattanooga arrived on the train and told the hotel that her husband would arrive within the next few days. He never showed, and after a few weeks of not paying her bills, the hotel had to turn her out onto the street. The only place that would take her was a nearby bagnio, so she stayed and began her new line of work.[35] While the majority of women in this line of work never escaped the squalor, some women were able to use this improper place in society to gain money and even power.

The wealthiest of these madams in Nashville had several properties and multiple prostitutes living in the same house. In 1860, a forty-one-year-old woman, Rebecca Higgins, owned real estate valued at $24,000, and her personal estate was an estimated $1,500. In today's money, Rebecca's property equaled over $650,000. Under her roof lived sixteen other prostitutes, a brick mason, a carpenter, eight children and a twenty-two-year-old free man of color (likely a servant of some sort). Eliza Higgins, Rebecca's sister, lived in this house and owned a twenty-three-year-old female slave. Rebecca had clout (and property) both in and out of Smoky Row. Unlike some of her counterparts in the sex trade, Rebecca's name rarely made newspapers, as she avoided doing anything that would land her in court. Although nobody officially recorded her influence, it is likely that her elite brothel serviced more elite clientele. She likely did not have to go court, as she was able to take care of legal matters in the bedroom.

Rebecca owned multiple properties in Nashville. She also had influence over multiple women of varying classes within the prostitution world. Two other wealthy prostitutes listed in the 1860 federal census, Mag Seat and Eliza J. Thomas, once lived with Rebecca. According to the 1850 federal census, seventeen-year-old Maggie Seat lived in Rebecca's house with five other single women, one of whom was Eliza J. Thomas. Over the decade between 1850 and 1860, Maggie came into her own right as a madam. In 1860, Maggie had ten white women working as prostitutes in her house.

Seeking their Level.

Two city officials were seen at a low down bagnio, on North College Street, at three o'clock Tuesday afternoon, in public view, fondling and caressing two of the vilest women of the town. Our informant states that he never witnessed a more disgusting spectacle, nor saw the city more disgraced.

Nashville's newspapers influenced public thought. During one of many campaigns to remove the unofficial red light district, this writer used his "informant" to apply pressure to city officials. *From the* Republican Banner, *July 30, 1868.*

In that same year, Eliza lived just a few doors down from her old mentor in her own house. Eliza J. Thomas owned $5,000 in real estate—$136,000 worth in today's money. Before Maggie and Eliza came into their own as independent businesswomen, they lived and trained under Rebecca Higgins. Not all of Rebecca's mentees grew their own businesses or established separate identities. Sarah Williams stayed with Rebecca for the ten-year interval between censuses. Higgins's household operations demonstrated the very high end of prostitution in Nashville—she proved herself as a savvy businesswoman.

Citizens of Nashville knew about the happenings within their city. Every once in a while, a new movement would surge against the houses of ill-fame within the city. The city aldermen would pass a new law, or the mayor would encourage the police to raid these houses. But they never fully eradicated the brothels. The city's *Republican Banner Steam Press* ran a tongue-in-cheek editorial for several years in the late 1850s about the assorted kinds who were brought before the judge in criminal court. Newspapers carried influence over public thought. While the editor used these stories as a source of entertainment, the paper chose to pass along thoughts about morality, too. An 1857 story reported that Kate Levine appeared in front of a judge for drunkenness. Kate was a teenager who found herself in trouble with her family—she got caught having sex out of wedlock. As a tale of warning and maybe compassion, the paper related Kate's sad story:

Only four short months since the unblushing culprit now before the Court was in a father's house, a loved and honored daughter—the pride of fond parents, and the hope of their declining years. But the spoiler came. In a fit of passion she fled from beneath the protecting aegis of a parent's care—carelessly and recklessly she sundered the hold ties of kindred—and seeking the stranger's roof, she found refuge in a moral pest house....Deeper

and deeper she drank of the embittered cup—lower and lower she sank the hopeless mirage which seemed to beckon her on, while no saving hand was extended to entreat her truant steps backward….She [found] *herself in the lowest depth—the most shameless and despicable hovel—reeking in drunkenness and with disheveled hair, and bewildered gaze, ranting her wild frenzied thoughts amidst a group of her hardened and unsympathizing companions. Such is vice, and such is the ultimate fate, sooner or later, of its votaries.*

Unable to pay her five-dollar fine, Kate Levine was sentenced to break rocks in the workhouse. Kate fell, and society did not want to pick her back up. In addition to young women getting lost, the newspaper reported when sad deaths occurred in this world of vice. Jenny Myers overdosed on opium one Sunday night in 1859. A denizen of "the jungles" of Smoky Row, Jenny had her heart broken when her lover left her. "Since she could not hate the faithless Don Juan, she swallowed the poison to forget him."[36] Even among a world of distractions, Jenny found that she'd rather escape than live.

In another case of innocence lost, a young boy between eight and ten years old wandered the Nashville docks in 1857. He had no possessions except the clothes on his back. He stepped into a nearby shop and politely asked the storekeeper, "Mister, can you tell me the way to *Smoky Road?*" Seeing how young the boy was, the storekeeper asked why did the boy want to go to Smoky Road? The boy replied that he had two sisters who worked at Mrs. Higgins's place and he had not seen them in two years. The boy continued with his story: he had been living north of the city with his father and brother when the two of them left for Illinois. So the boy decided to hunt for his sisters. Prostitutes living with their children, siblings or other young relatives proved a common household structure in nineteenth-century Nashville. The newspaper reporting this story ended with provocation about morality: "Should he discover his sisters in the 'smoky road,' and find a haven with them, being deserted by all else, it will prove a smoky road in truth to him….How many thousands there are of both sexes who are thus involuntarily thrown without the pale of hope?…Should we not deal more gently with the erring?"[37]

4
NASHVILLE'S FRAIL SISTERHOOD

The value of Nashville's location along the Cumberland River not only provided for a large shipping industry but also made it an enticing city for armies during the American Civil War. Nashville's bustling riverfront and surrounding men's district remained an eventful place, especially during war years. Nashville's wartime population included a large number of soldiers looking to pass their time between battles. Soldiers passing their time with Nashville's prostitutes meant an increase in disease spread among troops. That ultimately caused the military leadership to regulate the world's oldest profession. Nashville was the first city in the United States to legalize prostitution.

The four years of civil war that stretched between April 1861 and April 1865 affected the nation in many ways. Confederate forces fled middle Tennessee in February 1862, and the Union army took Nashville. It was the first Confederate state capitol to fall, serving as a huge boost to Union morale. For the rest of the war, Federal troops occupied Nashville. The self-proclaimed Athens of the West found itself contending with large masses of soldiers, refugees and newly freed slaves. Churches became hospitals, and houses became headquarters. At times, tens of thousands of United States soldiers camped out in Nashville. The influx of male beings in the city drew a variety of wartime distractions, including an increase of prostitutes. Hospitals absorbed hoards of soldiers due to sexually transmitted diseases. While the sex trade was not new in the city of Nashville, the high rate of military members contracting venereal diseases caught the attention of the

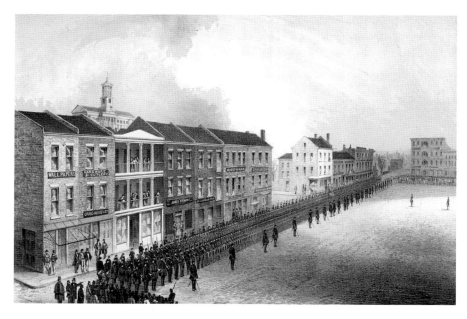

The Union army arrived in Nashville in April 1862 and occupied the city for the remainder of the war. *Library of Congress.*

army, and the leadership decided to do something about it. Disease, veiled in the cloak of morality, drove the local leadership of the Union army to address the issue of prostitution directly.

As early as the ninth century, Europeans used mercury as a means to treat syphilis. The aphorism "A night with Venus means a lifetime with Mercury" lingered into the nineteenth century. Civil War soldiers used this saying as a reminder about the consequences for any sexual encounter outside of the marriage bed. Venereal disease treatments in the 1800s included administering mercury topically and internally; this medicinal treatment often resulted in more harm than the infection itself. Published doctors of the era advised against the use of mercury, opting instead for using "injections of lead, sulphate of zinc, or nitrate of silver." Prostitution, and its associated illnesses, abounded throughout the United States during the Civil War. "It is impossible, even under the most rigid of discipline, to prevent gonorrhea among soldiers," wrote one doctor regarding the treatment of diseases. He further advised, "The army is no place for soldiers laboring under secondary or tertiary syphilis; the sooner they are dismissed from the service, the better." Attrition was not an option for the

Union soldiers occupied
Nashville during the Civil War.
Hundreds, if not thousands,
of prostitutes profited from the
soldiers' presence in the city.
Library of Congress.

army. The army in Nashville initially took some drastic measures to remove the issue that seemed to be spreading through the camps at alarming rates. But the more the army tried to rid the city of the problem, the more the problem grew.[38]

Nashville's Smoky Row received its name from the reported haze lingering on the street and in the alleys, but its most notorious activities revolved around sex. Prostitution in many forms ran rampant before war arrived, albeit in the shadows of society. An 1860 Memphis newspaper issued an editorial about Nashville's prostitution, claiming that the city's 1,500 prostitutes needed personal reform, since the law wouldn't stop them: "The police seem to put no check on this misconduct." Nashville's own reporters had opinions about these places, too. In May 1863, a newspaper reporting about a fire that burned down a local bagnio wrote, "The thing needed purification and got it."[39]

Wartime contributed even more complexity to the issue and hierarchy of prostitution. Tavern workers or boardinghouse mistresses might have traded sexual favors for protection or money but not considered themselves prostitutes. The regular female citizens—with their male providers gone—may also have resorted to providing sex for basic necessities. In 1864, the *Nashville Daily Union* commented on the issue: "To such an extreme are the unfortunate families of soldiers driven, that the women in towns and cities, as a last resort, take to a life of prostitution. So general is this that the name 'war widow' has become synonymous with a life of debauchery." The uncertainty of war clouded the lines of morality.

By 1862, in the midst of the Union army's occupation of the city, the population of prostitutes surged into the thousands. Not only did the location of the Smoky Row by the wharf provide easy access for the newly arrived sex trade workers, but also the abundance of men in uniform willing to spend money on imprudence gave rise to the Cyprian population. Medical understandings, or maybe misunderstandings, of the nineteenth century meant that many associated the sexually transmitted diseases as being rooted

in the sinful activities—prostitutes must be the origins of disease because of the wicked practice they plied. This understanding of where venereal diseases came from drove the army to make the decisions that it did.

For wartime Nashville, the abundance of prostitutes who were becoming more public caused a stir. Well-behaved society insisted that these behaviors, and the women associated with them, should be removed. At the very least, those participating in these activities should be pushed back into the shadows where they once quietly existed. The military leadership also desired that these ladies would go somewhere else. One soldier boasted about the prominence of the sex trade in Nashville in a letter: "There is [*sic*] four whorehouses here where a man can get a single jump for 3 dollars, five dollars [for] all night in Tennessee money."[40] The prevalence of these women and their profession couldn't be ignored. As the civilian population began a crusade against the world's oldest profession, the army also got involved.

The Federal army in Nashville witnessed that venereal diseases caused soldiers to fall ill at alarming rates. In the winter of 1862, Captain Ephraim A. Wilson made a note about the initial deportation in his memoir:

During the winter of '62 and '63 the army had a social enemy to contend with which seriously threatened its very existence and usefulness, and the matter became so seriously alarming that the military authorities at the Post had to interfere to save the army from a fate worse, if possible, than to perish upon the battlefield. I refer, of course, to the demi monde, *or, in other words, the women of the town.*

Their influence and presence became so annoying and destructive to the morals of the army that…[they] were compelled to leave…and Nashville was afterward all the happier and better off for their conspicuous absence.[41]

The army was less concerned about the destruction of morals and more concerned with the soldiers not being useful because they had contracted a sexually transmitted disease. The rise in illnesses did not show signs of slowing down. Reportedly, by July 1863, Brigadier General R.S. Granger was "'daily and almost hourly beset' by the commanders of regiments and their surgeons to devise some way to rid the city of the diseased prostitutes infesting it." The city had absorbed thousands of soldiers recovering from the Battle of Stones River—in Murfreesboro early in 1863—in addition to dealing with sick soldiers. Factories, churches, houses and public buildings had been converted into twenty-three makeshift hospitals. The increasing number of newly diseased soldiers served as an unnecessary burden to the

hospital staff and city resources. The commander of the Union army in Nashville needed to address the issue of local prostitution as a means to combat the disease spread. So he did.

Union officials seemingly could not control the soldiers from visiting the prostitutes, so the army attempted to remove the problem. Union commander William S. Rosecrans issued an order to Lieutenant Colonel George Spalding to "seize and transport to Louisville all prostitutes found in the city or known to be here."[42] Colonel Spalding followed through with his orders. On a sweltering July day, Union soldiers swarmed the known brothels, banging down doors to capture any of the prostitutes. One reporter of the event described "squads of soldiers…engaged in the laudable business of heaping furniture out of the various dens and then tumbling their disconsolate owners after." The army forced the captured women onto a steamship, often not allowing the women to pack even a change of clothing. The soldiers gathered a total of 111 white women, loaded them on the newly built steamship *Idahoe* and sent them upriver. Locals viewed the commotion as a positive thing for the city, and one newspaper even suggested readers to "bid farewell to these frail sisters once and for all." Captain John Newcomb received orders from Colonel Spalding: "To the captain of the steamer *Idahoe*. You are hereby directed to proceed to Louisville, Kentucky, with the 100 passengers put on board your steamer today, allowing none to leave the Boat before reaching Louisville." Even though he had no food or supplies for the women on board, Captain Newcomb had no choice but to set sail.[43]

The giant wheel of the *Idahoe* churned its way up the Cumberland and the Ohio Rivers with its precious cargo. Captain Newcomb intended to dock at any other port city and unload the women. That proved more difficult than what he imagined. Port city after port city kept refusing the *Idahoe*'s load, although the ship's cargo did not refuse any of the city's locals. Newspapers reported that the women still practiced their trade on the ship. Louisville refused to accept the *Idahoe*. Twelve women jumped ship, swam to shore and were promptly arrested and fined for their work. The captain of the ship acknowledged that the reputation of the boat as "a floating whorehouse" echoed beyond the ports, and sometimes local city leadership would even be present to turn away the *Idahoe* personally.

A few days after leaving Louisville, the ship arrived in Cincinnati, Ohio. The *Cincinnati Gazette* reported that the boat had over 150 women onboard and there did not "seem to be much desire on the part of our authorities to welcome such a large addition to the already overflowing numbers engaged in their

peculiar profession." The *Cleveland Morning Leader* made note of the women's conditions, decrying that "the majority are inveterate chewers of tobacco, and 'up to snuff…[they] are a homely, forlorn set of degraded creatures. Having been hurried on the boats by military guard, many are without a change of wardrobe.…Several became intoxicated and indulged in a free fight, which resulted without material damage to any of the party, although knives were freely used." While at Cincinnati, Captain Newcomb received word from Washington to return to Nashville. After twenty-nine days, the frail sisters would find themselves back at the port city that initially expelled them.

Even as Captain Newcomb and his shipload of women floated upriver, the city of Nashville still had a problem with its Cyprian population. The women who were captured and sent away were predominately white. While the number of prostitutes shrank slightly, the percentage of women of color working in the sex trade grew enough that local newspapers commented on the shift in population: "So barefaced are these black prostitutes becoming, that they parade the streets, and even the public square, by day and night. An order has just been received notifying all the white prostitutes to leave town immediately. Why not issue a similar order against the blacks?" The soldiers' demand remained the same, however. Colonel Spalding likely received word that his steamship endeavor was flawed and failing so he did not attempt any further efforts to banish the remaining sex trade workers.

The steamship *Idahoe* returned to Nashville and unloaded its denizens. The *Nashville Dispatch* reported that crowds gathered at the wharf to see the "precious freight" arrive, expecting the ladies to "resume their former modes of life." The Union army had the unsolved and now public issue of prostitution in this occupied city. Efforts to shut down brothels or dens of prostitution did not do much to slow the sex trade. Realizing that he could not stop prostitution, Colonel Spalding decided to regulate it. On August 20, 1863, Spalding issued this order:

> *1. That a license be issued to each prostitute, a record of which shall be kept at this office, together with the number and street of her residence.*
> *2. That one skillful surgeon be appointed as a Board of Examination whose duty it shall be to examine personally every week, each licensed prostitute, giving certificate of soundness to those who are healthy and ordering those into hospital those who are in the slightest degree diseased.*
> *3. That a building suitable for a hospital for the invalids be taken for that purpose, and that a weekly tax of fifty cents be levied on each prostitute for the purpose of defraying the expenses of said hospital.*

4. That all public women found plying their vocation without license and certificate be at once arrested and incarcerated in the workhouse for a period of not less than thirty days.

The army turned a residence of a former Catholic bishop into the required "building suitable for a hospital." Located on Market Street, Hospital Number Eleven was sometimes referred to as the "Pest House" or the "Female Venereal Hospital." Dr. William Mortimer Chambers, a fifty-year-old military doctor from Kentucky, was the "skillful surgeon" assigned to manage the hospital. He wrote a thorough official military document, "Sanitary Report and Conditions of the Prostitutes," about his efforts, medical opinions and research. In this report, he made note that prior to serving women, the building previously served as a smallpox hospital. "Guards are furnished from the Provost Marshal forces, whose orders are to admit no person on any pretext whatever, unless accompanied by myself. No profane or indecent language is allowed under penalty of solitary confinement. Patients are not allowed under any pretext to leave the hospital

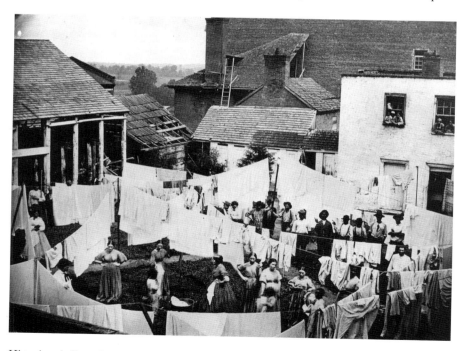

Historians believe these women are standing in the yard of Hospital 11, or the "Pest House." If true, this image serves as the only known image of Nashville's Civil War prostitutes. *Courtesy Tennessee State Library and Archives.*

untill [*sic*] they are perfectly cured." The "comfortably furnished" reception room greeted the patients as they entered the hospital. The examination room, adjacent to the reception room, contained a bed and table and the doctor's tools.

After the examination, women "found free from contagious venereal disease" could leave the doctor's office with a signed certificate. The women then had to take that signed certificate to the Provost Marshal's Office. There the women would receive a license to continue practicing their trade. If, however, the women showed symptoms of a venereal disease, they were sent to one of two wards within the hospital building to receive treatment. Prostitutes caught working without a license would spend thirty days in jail. All new arrivals of the profession to the city were to report to the provost marshal so they could be escorted to the doctor for examination and certification.

Dr. Chambers initially suggested that the workingwomen visit him every fourteen days. Soon after the hospital was established, he shortened the length of time between visits to every ten days. Each visit cost the patient one dollar, and the hospital kept thorough accounting records. The U.S. General Hospital provided the beds, mattresses and medicines. Dr. Chambers expressed his opinion that he felt no guilt about having the army pay for the supplies, as "the Army was deriving the greatest benefit from the Sanitary measures which they were helping to sustain: moreover all Medical Directors and Medical Inspectors who have been on duty in this Department have heartily approved the plan." He saw that this system could easily be sustained by using the funds from the examination fees to pay for whatever the army provided at cost. The army benefited by reducing the number of infected soldiers, and the women benefited by having access to some form of healthcare while being able to practice their trade without fear of being arrested or fined.

There existed a hierarchy, and the class system within the prostitute population dictated how the women were treated. In addition to examining women at the hospital, Dr. Chambers developed an arrangement to make house calls. Kept women and madams worked at the top tier of this hierarchy. They often maintained nicer quarters or houses, dressed more elegantly and charged higher prices for their work. These women dressed well and could easily pass as regular individuals. Their reputations, however, meant that most of the local citizens still knew who these ladies were. The kept women and madams were usually wealthy. For an additional dollar fee, Dr. Chambers would grant them the ease of not having to take time out of their

The federal government created the U.S. Sanitary Commission in 1861 to assist sick and wounded soldiers. The number of soldiers sick from venereal diseases forced the U.S. Army to address the issue of prostitution in Nashville. *Library of Congress.*

day to come to the Female Venereal Hospital. Having these wealthy women in a public light made some Nashvillians uncomfortable. A local newspaper editorial in November 1863 speculated, "Prostitution airs itself daily on our streets....We heard but the other day of a man and his prostitute, whom he had passed off for as his wife, being driven from a respectable boarding house. It will not be long before the doors of boarding houses and hotels will be closed against all females coming here who have not good vouchers for their respectability."[44]

As an experiment, the regulation and licensing of prostitution decreased the local venereal disease epidemic. It also contributed to the medical profession's understanding about how the contagions worked. Prior to the American Civil War, many believed that the source of venereal diseases began with prostitutes—sin's consequence. Dr. Chambers made note about his observations regarding the disease's spread. From the time he began his work in August 1863 until February 1864, "the ratio of the disease was fairly established." However, in February 1864, reenlisted volunteers began returning to Nashville from their homes after a furlough. Dr. Chambers reported that "with them [the] number of the venereal patients in both the male and female wards under my charge greatly and astonishingly increased." The increase in venereal diseases caught the doctor's attention, and he began investigating the sources of the spread. Out of 2,330 male soldier-patients treated for disease, only 31 reported contracting the disease in Nashville. While it is likely that many of the reporting soldiers had the disease but didn't show symptoms of it until after leaving Nashville, the study provided information for the medical profession. Dr. Chambers further made notes that the number of female patients being treated increased when new groups of soldiers arrived from other areas.

The safety net for these women workers slowly vanished, as the Union army's occupation of Nashville began dissipating in 1865. The army returned the venereal hospital to civil authorities in October 1865, and by January 1866, it had reverted into a smallpox hospital. Prostitution remained in the city, settling in less public areas of town known for their dens of vice. The local citizens went to work establishing legal boundaries to restrict and repress prostitution. In March 1866, the city council passed a Prostitute Bill to prevent any citizen from walking or riding with prostitutes in the public streets. Houses of ill-fame lost legal protection but would maintain a stream of steady, and often elite, clientele.

For brothels and gaming houses alike, serving officers of the court, politicians or law enforcement provided some level of protection. Raids and arrests happened often enough to appease the public, but the businesses were still allowed to continue to operate. At one point in 1868, the court made an agreement with the madams: the madams should consider themselves arrested the first of every month for plying their trade and pay any officer who came by the bagnio their five-dollar fine. This arrangement seemed to free up both the police department's and the court's time to enforce more dangerous criminal activity. Evidently, the city of Memphis had implemented a policy similar to this, and Nashville decided to give it a try.

Slowly, the city slipped into a postwar world, filled with new struggles. What should society look like now that slavery had been abolished? The location of the city suited new arrivals well, and the population of Nashville grew from just over fifteen thousand at the end of the war to almost seventy thousand in 1885. Prostitution remained, but it would never again be publicly acknowledged or treated like it had been during the American Civil War.

MORE TEASE LESS STRIP

*I*n its earliest forms, burlesque shows did not involve stripping. In fact, some early burlesque shows almost exclusively involved casts of entirely clothed men. The word burlesque originates from the Spanish *burla*, meaning "joke." The initial burlesque performances were comedies—performances that exaggerated and mocked characters or traditional styles of entertainment. Beginning in the 1830s, London hosted a variety of these burlesque shows. This type of entertainment evolved to include casts of women, often dressed as men, as a form of mockery. For Victorian sensibilities, however, women wearing tights that exposed their legs fell into the category of wildly scandalous. Nashville hosted a variety of burlesque shows in its history that evolved into notorious striptease performances in the twentieth century.

Burlesque shows arrived in the United States in the late 1860s with a traveling troupe: Lydia Thompson and the British Blondes. As burlesque shows grew in popularity in the United States, the show itself evolved and absorbed American styles of performing. These shows mimicked the minstrel show, included songs, comedy sketches, acrobatics and magicians and finished with a chorus performance or a burlesque performance on politics or current events. The women wore extravagant costumes with revealing skirts, tights and snug-fitting dresses that exaggerated bosoms.

Just three years after Lydia Thompson first arrived in the United States with her troupe of British Blondes, her troupe performed in Nashville. Led by Lisa Weber, the troupe stayed at the Maxwell House and performed in

the Masonic Hall. An editorial wrote of the performance, "Miss Weber is a sprightly little lady with a good voice and a fine face and figure. In the character of 'Ernani' she showed herself well versed in burlesque impersonations, and was encored every time she sang."[45] While some frowned upon these shows, the newspapers tried to justify these performances with theatrical reviews. About one burlesque performance of *Romeo and Juliet* at the Grand Opera House, a Nashville editor reassured audiences, "The costumes were magnificent and tasteful." The actors performed the story with a contemporary setting of Nashville; most of the burlesque in this particular performance rested in the jokes written about, and sometimes even mocking, the city.[46]

The greatest scandal of early burlesque shows were the performers' use of short skirts and revealing tights. *Library of Congress.*

One of the more famous of the female performers to make appearances at theaters in the men's district was Eva Tanguay, the "I Don't Care Girl." Eva began her career as a vaudeville performer: "The girl who made Vaudeville famous." She was hailed as an independent woman who sang songs like "It's All Been Done Before but Not the Way I Do It," and "I Want Someone to Go Wild with Me." Her most famous song, "I Don't Care," captured her cheerful, independent personality:

I don't care, I don't care,
What they may think of me,
I'm happy go lucky,
Men say I am plucky,
So jolly and care free,
I don't care, I don't care.[47]

Among things Eva didn't care about included her reputation; she often used wild stunts as a means to promote her shows. In Louisville, Kentucky, Eva used a hatpin to stab her stagehand. She settled out of court for $500

Women dressed as men and playing the roles of men in burlesque shows proved humorous. Burlesque shows often used the humor to present satire. *Library of Congress.*

The Grand Opera House served as one of the more proper theaters to host burlesque shows. *Library of Congress.*

but gained further publicity by having her name printed in the newspapers for her rowdy behavior. Her vivacious personality sold out shows for several seasons in Nashville.

The location and notoriety of the theater altered the type of show, as well as the type of audience. A show in the Grand Opera House presented shows considered acceptable in Victorian taste. Nashvillians encored the likes of Eva Tanguay while ignoring the presence of more scandalous shows in the men's district around Fourth Avenue or on lower Broadway. Another venue type, concert saloons, developed specifically for men's entertainment around the end of the 1850s through the 1880s. These places became America's answer to English performance halls with a twist—women would both serve and perform small shows while men drank. It allowed for the establishments to captivate the patrons and serve more alcohol; serving more alcohol made the saloon owners more money.

In New York City, these concert saloons prompted an editorial about morality that many nationwide newspapers printed. The *Nashville Union and American* printed this editorial on January 2, 1866. It explained how these establishments should be considered somewhere between brothel and opera house. The women who worked at these concert saloons were just a step above whores, explained the newspaper: "Most of the songs expected are the whispers of the little waitress who brings you liquor....All of these girls are fallen, but none of them fallen far. Some show signs of polish in their choice of words, and all are quick-witted." This created a stir in the city—which hosted its own set of concert saloons—and the city council created a committee to develop a report about the affect of these places. The council needed to investigate the sites for themselves if the concert saloons were, in fact, "flagrantly lewd" and "detrimental to public morals." The committee found that indeed these "place of entertainment are dangerous pitfalls of vice, set to ensnare the feet of unwary young men, who through them fall to deeper depths of degradation and crime." Within three years, the city council began its efforts to pass bills restricting liquor sold at places of amusement and outlawing women waitresses. Even as the city worked to remove these older styles of amusement, new forms of entertainment crept in, including a dance featured at the Varieties saloon on Broadway called "the can-can."[48]

Depending on the class of its patronage, these places of entertainment did not cease to exist. The men's district on what became Fourth Avenue adjacent to the Maxwell House hotel served elite clientele, and places that generated money could either pay for protection or easily just pay its illegal fines. The men's district served many individuals who worked in the vibrant printing industry of the city. At its height, Nashville hosted dozens of independent publishers or newspaper houses. With the newspaper offices of the *Nashville Banner* and *Nashville Tennessean* nearby and additional printers and publishers surrounding the alley, this became one of the notorious locales that continued offering a variety of vice. Hotels and restaurants like the Southern Turf, the Utopia and the Climax hosted meals, booze and shows that often featured scantily clad women in this men's district. Printers Alley ran on the backside of these hotels, parallel to the men's district, and started as what the name suggests: an alleyway attached to places where printers worked. During Prohibition, these businesses officially closed their front doors to serving liquor and moved their entrances to the area known as Printers Alley.

Printers Alley, an alley made up of the back doors of the men's district, became synonymous with backdoor behaviors; illegal liquor, drugs and

Burlesque performers in the nineteenth century danced, sang, performed comedy routines and acted out scenes from plays. *Library of Congress*.

—Staff photo by Jack Corn

Rainbow Brightener

Margaret Noel McKennzy, better known as Harlow Angel, brightens the darkness outside Skull's Rainbow Room in Printer's Alley where police raids have turned her strip tease act into more tease and less strip.

Harlow Angel posed for a newspaper photographer in a Printers Alley's doorway. *From the* Nashville Tennessean, *January 1, 1973.*

women could be easily obtained here. As the twentieth century progressed, burlesque shows evolved from dancing women with revealing clothing to stripping dancers. Bars that once hosted concert saloons and female waitresses became places that hosted scantily dressed barmaids and featured striptease shows. Printers Alley became so well known for its stripteasing that a local judge commented about the place to a local newspaper: "I used to enjoy going down [to the Alley] to see Heaven Lee (a nightclub stripper) when she was here. I guess if you classify naked by degrees you have naked, nakeder and nakedest. I don't see how you can get any 'nakedest' than Heaven Lee."[49]

Women dancers like Harlow Angel, Heaven Lee and Miss Connie entertained diners and drinkers with their burlesque at several spots in Printers Alley. A local reporter treated himself to a show as a form of an exposé: "'Miss Connie' began her act wearing a sheer negligee, and little else. During her 10-minute act, she pranced about the stage and—amazingly—produced lollipops which had been hidden somewhere in the 'little else' she was wearing." These women shimmied, bounced and wiggled their way out of their clothing during these shows. Sometimes, they'd leave the stage with pasties and a g-string. Other times, they'd exit the stage with nothing.[50]

Usually, the law turned its eyes away from what was happening at Printers Alley. In fact, police officers frequented the establishments, oftentimes in uniform. In 1973, after her show, a stripper at the club called the Black Poodle grabbed a patrolman's hat and playfully ran to her dressing room with the officer in gleeful pursuit. His partner just grinned as he watched the shenanigans. Systematic raids never really stopped the shows in their entirety. After a raid, the dancers would ensure they didn't bare all for a while as a means to abide by the rules. Over time, however, the ladies revealed more skin. A raid would occur, and the "nakedest" of dancers would reset the strip cycle, only taking off most of their clothes.

The Rainbow Room and the Black Poodle were only two of the famous bars located in Printers Alley in the second half of the twentieth century. *Library of Congress.*

In the later half of the twentieth century, Printers Alley became an attraction; visitors could find venues that played country music sets, venues that had comedy shows or venues with striptease shows. In the case of Skulls Rainbow Room, patrons could find all three on one stage. The idea to combine all three acts was the brainchild of David "Skull" Schulman, the owner of Skulls Rainbow Room.

Skull opened his original establishment in Printers Alley in 1948, called the Basement Bar. He began the endeavor with colleagues Mickey Krietner and Jimmy Hyde. They would go on to open other clubs in the Alley, the Captain's Table and the Carousel Club, respectively. In this era, limited places downtown had live shows, and no place could legally serve liquor by the glass. Traveling salesmen and folks in town for conventions found themselves at Skulls. His was a mixing bar—patrons could bring their own bottles of liquor—and bartenders were only allowed to mix drinks, not sell hard alcohol. Some patrons continually returned on their trips, and Skull recognized them by name. After 1966, patrons could order alcohol by the glass, and business boomed even more.

Skull Schulman worked in Printers Alley for over fifty years. Known for his love of country music, his poodles and rhinestone suits with embroidered poodles, Skull became an icon in his own right. As a child, he sold copies

Above: One of the many raids on bars located in Printers Alley. Prior to 1966, bars in Nashville could legally mix drinks but not sell the alcohol; patrons had to bring their own. *Library of Congress.*

Left: David "Skull" Schulman standing with Nudie, a designer of the iconic Nashville rhinestone suits. Wearing rhinestone suits became one of Skull's trademarks. *From the Nashville Tennessean, October 8, 1957.*

of the *Tennessean* for three cents apiece. At that time, the *Tennessean* still operated out of a building on Printers Alley—the same building Skull would eventually use for his bar. Self-proclaimed "Mayor of Printer's Alley," he told passing visitors about his newspaper history, the history of the alley or his dogs. In total, Skull owned over twenty-five poodles in his lifetime. He was often seen in his *Hee Haw* overalls sitting outside his bar with them.[51]

Skull influenced the country music industry in minor and often discreet ways. He loved the television show *Hee Haw* and frequented tapings of the show. In its early days, Skull provided food and drinks to the cast as a way of showing his support. In return, *Hee Haw* adopted Skull as an honorary cast member. Skull's generosity spilled into the Nashville community. He arranged for holiday shows at a local children's hospital, bringing in food and gifts from other businesses as donations. On more than one occasion, he arranged to have country music stars perform, and at times, he was able to get the cast of *Hee Haw* to attend these holiday parties. As he grew older, he traded his sequin suits for *Hee Haw* overalls. He did not stop inviting young musicians to come and play at his bar, especially after 1989, when he turned the Rainbow Room into a country and western bar. Even after they became famous, musicians like Waylon Jennings and Willie Nelson would still drop in and play at his bar every once and awhile. Printers Alley even found its way into country music, likely to Skull's delight. In Waylon Jennings's 1980 song "Nashville Wimmin," he sang: "Going down the alley to see what I can find, Goin' down the Printer's Alley gonna look around and see what I can find; Let some Nashville woman take me home and blow my mind."

Skull told a reporter in 1986 that he had "not once missed a day of work since he opened the Rainbow Room," and he would stay there until the day he died.[52] That day came in 1998, when Skull was attacked and murdered during a robbery at the Rainbow Room. He was found with his skull fractured and throat cut and no indication of who committed the vicious act. Skull was taken to Vanderbilt University Hospital the night of the robbery, unconscious and rasping haggard breaths. When she heard the news, country music singer Tanya Tucker rushed to the hospital that night to be with Skull. She sang softly to him as he lay unconscious. "His lips were moving, he could hear," she told reporters afterward.[53] David "Skull" Schulman passed into the life eternal early the next morning.

Skull's murder shook Nashville, especially those in the music scene who knew him personally. The case went unsolved for over two years. Many country musicians contributed to interviews on a broadcast of *America's Most Wanted* television show about the case as a means to assist police in the hunt for

Skull Schulman wearing a rhinestone suit decorated with poodles. Skull loved rhinestone suits and poodles. *From the* Nashville Tennessean, *March 11, 1998.*

Skull's killer. Finally, a break in the case occurred in 2000. A janitor of another bar down Broadway tipped the police by reporting he recalled seeing two men the night of Skull's murder in the bar; one of the men had blood on his clothes. The police followed up with the lead and found the accused men: Jason Pence and James Caveye. James Pence pleaded guilty to facilitating a murder with a fifteen- to twenty-five-year sentence in exchange for his testimony. James Caveye claimed he was innocent, but Pence's testimony said otherwise. According to Pence, both men were living on the street at the time of the murder and needed money. Pence had once worked as a janitor at the Rainbow Room and told Caveye that Skull kept cash in the bib of his famed *Hee Haw* overalls. Pence stood as a lookout as Caveye attacked Skull, hitting the businessman with a liquor bottle after cutting his throat. Eventually, the men went their separate ways. Police found Pence in a mental hospital in Nebraska and Caveye in jail in San Francisco. At the end of the trial, the jury decided Caveye was guilty, and he went to prison for life.

Skull influenced Nashville in many ways, from encouraging the production of *Hee Haw* to launching the careers of famous country music stars and being one of the many individuals who have contributed to Nashville's unique character. In recent years, the Rainbow Room reopened in Printers Alley. The venue offers late-night burlesque shows that often pack the house. Although he no longer walks this earth, Skull undoubtedly remains the "Mayor of Printers Alley."

6

KNOX MARTIN

The evening of January 14, 1879, appeared like a normal, quiet, wintry night. John and Bettie Whittemeier bedded their youngest two children between them, and the four of them fell asleep under a shared quilt. Their five-year-old daughter, the eldest child, spent the night with her aunt about half a mile away. As the fire crackled in the fireplace to keep them warm in the night, Mr. and Mrs. Whittemeier were murdered at Bell's Bend. Their babies lay sleeping—and unharmed—between them. In the subsequent weeks, a chase, a trial and an experiment in bringing the dead back to life followed these brutal murders.[54]

Knox Martin, only eighteen years old, worked for the Whittemeier family during the late autumn and early winter of 1878. Having recently moved to Nashville from rural Alabama, he was glad for the work. Eventually, he left the job to work closer to where he lived in Nashville. However, he understood that his former employer, John Whittemeier, still owed him for his last day's wages. Knox paid John a visit in early January in order to collect those wages. He arrived only to be physically threatened by John. Knox left John's farm in a hurry. Later that day, he told his friend, George Berry, what had happened when Knox went to go gather his earned wages. George said John Whittemeier had done the same thing to him when he worked for Whittemeier earlier in the year. The two men, being of African descent, feared they would not receive fair treatment if they pressed charges for their lost wages. Even though the Civil War freed over four million enslaved people, equality did not arrive immediately with that freedom.

Knox and George confided in Knox's aunt, who was considered the local neighborhood witch, and she gave Knox a warning. If he didn't kill John first, John would kill him. Her premonitions had come true before, so he took this fortune to heart, and the two former employees made a plan. George convinced Knox to go back to the Whittemeier farm later that evening to kill John. Knox believed he had to do this in order to stay alive.

They made the trek to the Whittemeier farm. George grabbed a rock for each hand and suggested to Knox that he acquire his own weapon. Knox picked up a wagon wheel spoke and they approached the cabin where John and his family slept. The door creaked open, and they eased across the floor. George raised the rock over his head and heaved it downward across John's skull. Knox took a swing next, but as his wagon wheel spoke came down, it hit Bettie, waking her.

"Kill her so she doesn't report us!" George spoke in a forced whisper.

Knox reacted and hit Bettie so hard that she fell back, dead. Knox saw that the two children still slept between their parents, and he raised the quilt to cover them. When he turned around, he saw George taking a roll of bills out of a drawer. "Take something to make up for your lost wages" George told Knox. Knox walked over and picked up a pair of pants, John's hat and overcoat, a few pieces of jewelry from a drawer and fifty cents from John's pocketbook. To remove any evidence, Knox tossed his weapon into the fireplace. The two left the farm and headed back to the heart of Nashville.

A little after 8:00 a.m., the aunt came back to bring the Whittenmeiers' daughter home. Abe Bloomstein, the owner of the surrounding fields, heard the screams. He rushed over to see why the women were screaming. John and Bettie lay bludgeoned and their two babies sat crying between them. By the time John's brother, Frank, arrived, several nearby neighbors had gathered. Blood spattered across the wall and the quilt. He spotted the bloodied rocks sitting on the chair next to the bed. While death itself would not startle nineteenth-century citizens, a brutal murder shocked those who heard about it. The scene left an impression on those few who witnessed the bloody aftermath of the Whittemeier murder.

Several physicians arrived as members of the coroner's jury. As rains flooded the ferry that provided access to the Whittemeier farm, word did not get back to Nashville about the severity of the murder until early on January 16. Once the news spread in Nashville, police began inquiring among the Whittenmeiers' neighbors, whom the police thought could prove as valuable witnesses. In the meantime, George and Knox thought it safest if they split up and lay low for a few days. George said he would keep an ear out if

he heard any local gossip about suspicions. Knox decided to stay with his brother, Peter Martin, on Cherry Street. George overheard a conversation that Knox had been spotted that night, so George went to Knox.

After understanding the local gossip that he might also be wanted, George Berry went to nearby Dr. Bloomstein to ask advice from the doctor. Bloomstein was the father of Abe, the man who heard the screams, and owned the parts of the property where the Whittemeiers farmed. George know Bloomstein would have been familiar with the news related to the property. George told a story to the doctor about how Knox Martin had confessed to the murder and Knox had showed George items he stole from Whittemeier. He described the rings that Knox had stolen and told Bloomstein that the rings were still in Knox's pocket. Dr. Bloomstein took George Berry to the local fire station, and they told the police officers there about Knox Martin. The police left immediately to find Martin.

Constable Uriah Peebles and Officer George Fletcher followed George Berry to the location where Knox Martin was hiding. Knox attempted to flee, but Peebles fired at him. Knox Martin dropped to the ground. The stray bullet missed its target and hit a little girl nearby. Uriah Peebles kept the pistol pointed at Knox until more officers arrived. The chaotic scene attracted a crowd, and in the officers' haste to take Knox to jail, they did not retrieve a mittimus. Without the court-ordered document, the jailer would not take the prisoner.

"Will you allow him to remain, then, while I go out and secure one?" asked Officer Fletcher.

"Certainly," replied Jailer Hinton.

While the arresting crew left to find a judge to sign the arrest order, a news reporter from Nashville's *Daily American* newspaper took the time to interview the suspect. Jailer Hinton sat next to the reporter and listened to what Knox Martin had to say.

Knox spoke in a calm, clear voice as he made his confession. He started by saying he had no intention to kill Bettie. He continued that it was Aunt Mary who warned him that if he did not kill John, John would kill him first. (The newspaper reporter made a note that she was a "well-known witch.") Knox recounted a story that he went to the farm, grabbed a wagon spoke and walked into the cabin. John Whittemeier sat up, and Knox "hit [John] only one lick, killing him." He confessed that the spoke was so long that the end of it reached across and hit John's wife in the same motion. Afraid she would tell, he hit her one more time and killed her. He said the babies slept through the noise, so he covered them up. He took John's overcoat, a pair of

black pants, a hat and fifty cents from John's pocketbook. "I did not eat any preserves afterwards," he added.

In his confession, he said he acted alone and the idea was all his own. He told the reporter that he stayed on the property until early morning hours, and when he left, he told George Berry what he had done. Knox said that George told him there was an article in the newspaper and advised Knox to hide while George made a plan to help Knox leave Tennessee. Knox went to his brother's house and stayed there until he heard the police coming for him.

Knox Martin gave no reason for his omission about George's involvement. Maybe he thought George could help him get out. Maybe he felt bad about his own deeds. He would not tell of George's participation until the day of his execution. By the time he was done talking to the reporter, the other officers had come back from getting their mittimus, and Officer Hinton booked Knox in the Davidson County Jail. The sheriff expressed concern that if Knox stayed in the jail, word would soon spread and a mob might show up. Since mob law often overruled the legal court system, the sheriff's concerns proved legitimate. Especially in cases where the accused was a person of color, like Knox Martin, mobs often acted as judge, jury and executioner, condemning the individual to a punishment of lynching. This practice happened all over the United States in the decades following the American Civil War; Nashville proved no different.

As a means of protecting Knox, the sheriff asked for a speedy trial. He wanted to lessen the chance of a mob lynching and see to it that the justice system had a chance to work. During the next several weeks, the only visitors Knox received were his brother and some clergy. Initially, a Baptist reverend visited, but soon Knox's most consistent visitors were of the Catholic faith. Father Veale and the Sisters of Mercy made daily visits to Knox. In fact, the sisters tended to Knox so well that he decided to convert to Catholicism. His brother tried to talk Knox out of the conversion, but Knox stayed diligent in his new course of faith. In addition to the Catholic visitors, Knox received boxes of gifts from family and friends. The reporter who took Knox's original testimony made note that Knox clearly gained weight—as much as twenty pounds—while he was held in jail. Jailer Hinton reported that Knox behaved quietly and properly throughout his time behind bars.

His trial began on February 25, 1879. Knox had access to a fair trial rather than the verdict of "Judge Lynch" in a field somewhere. For a man of color in the decades following the Civil War, this proved fairly

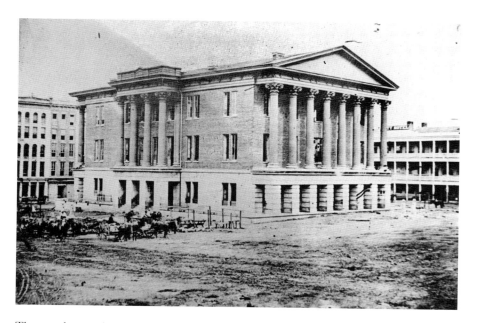

The courthouse where Knox Martin stood trial for the murder of the Whittenmeiers. *Library of Congress.*

remarkable. The trial lasted a few days and rested on the Whittenmeiers' personal possessions that Knox had in his person when he was arrested, his confession and George Berry's testimony. Knox did not take the stand for himself. Court reporters noted his calm demeanor during the trial, attributing this to his newfound shift in religion. The jury found him guilty, and the judge sentenced him to hang. While his lawyers and family encouraged him to appeal the verdict and take the court's decision to the Supreme Court, Knox declined. He told them he'd rather die than stay in jail and be potentially lynched during the time he waited. He told them he committed the act and figured he was going to die either way. With the strength of his faith, he told reporters that he was ready to die and wanted to go.

On the morning of Knox Martin's execution, Knox's brother, Peter, visited him. The newspaper made note that this meeting was the only time during Knox's confinement that anybody witnessed Knox shedding tears. He hugged his brother and wept. At exactly noon, Father Veale arrived to visit one last time with Knox. They were left alone for fifteen minutes, and then the jailer came to take Knox away. About three thousand people gathered around the jail. Anticipating the large crowds, the police force

arrived with forty officers and a wagon to take Knox to the execution scaffold. All along the route between the jail and the scaffold were masses of people and wagons. Wagons had been arriving since the night before with news of this public execution. The execution had become a public spectacle, and many mothers asked their children's teachers to dismiss the students in order that their children could watch the event. Even the scaffold location planned by the city rested between two hills so that there would be enough space for the anticipated crowds. Newspapers from places like Chicago sent special correspondents to cover the execution. This event quickly became the spectacle of the year, a news item carried in papers nationwide.[55]

The police escorted Knox through the hubbub of Nashville's excited

THE DEATH PENALTY.

Execution of Knox Martin, the Bell's Bend Murderer.

The local newspaper had Knox Martin's photograph taken on the day of his execution. The publication sold images at his execution. *From the* Daily American, *March 29, 1879.*

citizens. Knox remained calm during his ride. At one point, the wagon hit a bump in the road that caused a plank in the wagon to dislocate. In the jumble, Knox fell through the floor of the wagon, with his arms propping him up and his legs dangling below. A nearby reporter expressed his amazement at Knox remaining calm and joking about the incident. Knox did not project the emotions of what most people expected to see from a man about to hang from a rope. It appeared Knox made his peace with his Maker.

Prior to the execution, some doctors from Vanderbilt University approached Knox Martin about the use of his body for research. They wanted to expand their research on resuscitating bodies after death by using electricity. While experiments in bioelectromagnetics began as early as the 1790s, the doctors wanted to see what its use could be after death. Could a current awaken the dead if the body only recently died? Knox Martin agreed to the experiment and sold his body to the doctors for research. On the day of the execution, the doctors set up a tent near the scaffold. The tent was covered with tarps to keep out the morbidly

Vanderbilt University doctors used Martin Knox's body to test theories of bioelectromagnetics. After his death, his body was brought to the campus for further study. *Library of Congress.*

inquisitive. The researchers made an arrangement with the police to have Knox Martin's body after he was dead. The police agreed and confirmed they would ensure that Knox was completely dead before handing him over so that the experiment would not be ruined.

Doctors McMurray, Steger, Harwell and Summers ran the experiment. Knox Martin hung for fifteen minutes to ensure he was dead; then the police cut him down and gave his body to the doctors. The doctors worked in their tent. After resetting Knox's neck, the doctors "arranged the batteries and applied electrodes to the base of the brain and chest." As soon as they turned on the current, Knox's muscles began twitching. It appeared that Knox had resumed breathing, and his eyes opened. At one point, Knox's head lifted, and this caused a stir throughout the crowd. The experiment practically induced a lynch mob; murmurs of re-killing Knox circulated as news echoed about this experiment. The doctors quickly squashed those rumors—or so they thought.[56]

The electric current triggered responses in Knox's body that replicated him "arising from the dead," but he remained dead. The doctors removed him from the tent to Vanderbilt University in order to continue their studies, and the crowd eventually dissipated. Those in the crowd took home stories about seeing a man almost brought back to life. What any onlookers saw peeking through the tent flaps surely looked like Knox Martin rising from death. This provoked one man from Madison County, Alabama, to write a letter to the medical staff at Vanderbilt. He reported that a man calling himself Knox Martin walked through town on March

30, the day after the hanging. The man wondered if the experiment had worked and maybe he did not receive the news. "Is this Knox Martin dead or alive? Please write and let me know. There is some excitement here about him. I am not satisfied, so I ask you to write....Respectfully, James Mason."[57]

Who knows who, or what, wandered through Madison, Alabama, after Knox Martin's death?

7

CARDS, DICE AND JOHN BARLEYCORN

emptations of all sorts have existed in Nashville's history since before the town was founded. Alcohol-serving taverns arrived to middle Tennessee with the earliest Nashville settlers. Booze became a central character for most stories propagated from Smoky Row. As much as Nashville tried to battle the flow of the alcohol, it never really went away. When it flowed legally, it shifted from neighborhoods. When it flowed illegally, it moved underground. In addition to alcohol flowing, gambling became another moral travesty that caused the city to create restrictions. Both vices have a long and varied history in the city.

Lotteries emerged as one of the earliest form of gambling found in Nashville. In 1809, the state outlawed private lotteries that benefited individuals. However, citizens maintained a right to host semi-public lotteries as a means to pay off debts through the raffling of property. In that same year, the state approved lotteries that were designed to benefit public projects. Over time, the lottery fell into the same category as other types of gambling. Gambling became another, albeit more complicated vice, the city attempted to eradicate in the nineteenth and twentieth centuries.

As the nineteenth century progressed, so did the forms of gaming for money. Card games, dice games and table games became pastimes for some and pitfalls for others. Citizens fighting against gambling associated the activity with laziness, a penchant for criminality and drinking. Taxes levied against things like billiard tables were designed to deter gambling and, to some extent, the negative behaviors oftentimes associated with gaming for

Nashville had regulations for billiards before the city was even incorporated. *Library of Congress.*

money. If the city could remove the temptation to gamble, it could create better citizens.

Some styles of gambling did not originate as sinful deeds. Horse racing started as an event for elite citizens to compete. Horses served crucial roles in transportation during the early nineteenth century. Before Kentucky became famous for its horses, middle Tennessee served as a prominent horse breeding and raising place. Spectators assumed horse racing was a legitimate way to demonstrate the quality of thoroughbreds. This sport grew in popularity, and at its height, the area hosted three racetracks. Before becoming president, Andrew Jackson purchased horses and interest in a racetrack at Clover Bottom in Nashville. He earned more than $20,000 in wagers at the Nashville Clover Bottom Race Course. He was not the only president who participated in wagering on horse races, but Jackson was the last president to race horses at the White House during his presidency.[58]

By the 1850s, horse racing had become synonymous with gambling, but it did not lose its appeal to gamblers. While other styles of gambling were

Left: Considered a "gentleman's game," billiards became popular in the mid-nineteenth century. *Library of Congress.*

Below: Interior shot of the Maxwell House Hotel. *Courtesy of Metro Nashville Archives.*

branded as evil, horse racing continued to be considered "the legitimate sport of the gentry."[59] The fight to restrict the hobby continued, and as fiery preachers passed through with their messages of morality, horse racing was added to the long list of sins. Tennessee passed an anti-betting law in 1906, finally bringing this form of gambling to an end, at least for a while. Middle Tennessee hosted many horse farms, and the legacy of horse racing never went away; eventually, horse racing crept back into the area as a spectator sport.

Another form of elite gambling arrived by way of billiards. Considered a gentleman's game, billiards did not inherently mean gambling. Wagering against a game, however, became a pastime for players and speculators alike. Nashville's earliest acknowledgement of the game happened in 1801, when the city levied a five-dollar annual tax for billiard tables hosted by public places. Eventually, the city developed more regulations and levied more taxes. The privilege of hosting a billiard table or a ten-pin alley "for the purpose of public amusement," cost twenty-seven dollars a year for Nashville businesses in 1836.[60] Efforts surged at different points in Tennessee history to demonize and outlaw billiards. The gambling aspect of gaming followed as a side activity. "Poolroom" refers to the pool of money surrounding a wager, not the game of pool itself. Poolrooms developed in conjunction with billiard rooms, although the spaces served different purposes—one was to game and the other was to gamble on games. The gambling aspect of billiards begged questions about morality. During one of the campaigns against it, a senator speculated how billiards might destroy society: "The vice of gambling which will eventually be attending with pernicious consequences to society, by corrupting the morals of the youth of our country."[61] The game was not meant for youths, but youth became yet another reason to fight against it.

For privileged clientele, billiards rooms were available at respectable places, like the Maxwell House Hotel in Nashville. The Maxwell House Hotel stood along part of Cherry Street, where other venues for men's entertainment drew the attentions of wealthy white men. Nashville's polite society barely tolerated gambling in places like the men's district. When it happened in slums, like Hell's Half Acre or Black Bottom, gambling was viewed as an evil threat to society.

The location of these games either meant police raids or payoffs; wealth, skin color and ethnicity usually made the difference if law enforcement looked the other way or broke up the game. The men's district along Cherry Street (now Fourth Avenue) hosted clientele with money. At best, the gaming houses could pay off police; at worst, the gaming houses paid their misdemeanor fines and continued playing. However, in poorer neighborhoods or neighborhoods with darker racial demographics, gambling was prosecuted fully. One of these neighborhoods received a lot of extra attention for the nefarious happenings. While some argue that the origins of this particular neighborhood's name, Black Bottom, came from the location near the river and abundance of mud, the prominence of people of color in the area (and the mention of their skin color in editorials, newspapers and public

The Maxwell House Hotel on Church Street provided wealthy men easy access to the entertainments of Cherry Street. *Courtesy of Metro Nashville Archives.*

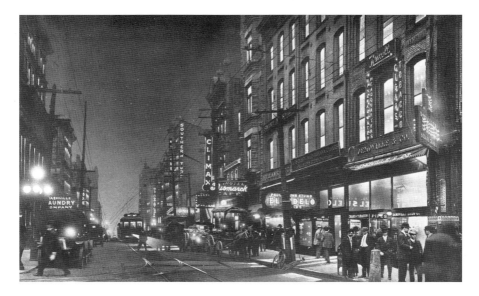

Cherry Street, eventually renamed Fourth Avenue, became the center of the men's district. The Southern Turf and the Climax can be seen in this photo. *Courtesy of the Tennessee State Library and Archives.*

outcries) suggests the name was actually derived from the demographics of the neighborhood.[62]

Black Bottom and Hell's Half Acre were neighborhoods targeted by authorities as a means to demonstrate that city leaders were doing something about vice. Even though the same vice existed around the Maxwell House Hotel and in the men's district, it was easier to prosecute poor citizens for the same crime. Having groups of people available to take the fall for immoral activities gave newspapers a reason to publish how the city acknowledged and "dealt with" criminal activities without actually causing trouble for citizens with money or power. Demonizing these poorer areas as "abodes of vice" helped fuel efforts to target them in raids or stings. Reports of the slums came out about how terrible these places were: "This [Black Bottom] is notoriously the worst section in point both of bad sanitary government and abject immoralities that exists in Nashville. It is here that the most depraved specimens in the whole race, here or elsewhere, may be found."[63] Violent crimes happened in Black Bottom—as well as over along the men's district—but the men's district was never portrayed as being as horrible as Black Bottom.

Black Bottom became Nashville's new Smoky Row, with a more diverse population within its neighborhood. While Smoky Row hosted its fair

share of both free and enslaved people of color, it reached its peak during an era when the majority of Nashville's African American citizens were enslaved. Now that a neighborhood filled with vice contained citizens with more complex skin tones, some white elites used that as their reason to target these places. The population of the city nearly tripled between the beginning of the Civil War and the 1890s. The city held promise for many individuals escaping their war-torn lives. The city also held promise for newly freed slaves. When multitudes of people arrive to a city during a short period of time with few possessions and little money, however, poverty follows. The high levels of poverty settled in the areas known as Black Bottom and Hell's Half Acre. Rather than addressing poverty as a social issue, many citizens equated it with moral wrongdoing. Nashville newspapers made comparisons of these neighborhoods with reports coming out of New York City. By describing these neighborhoods as both sin-ridden and dangerous, just like the neighborhoods of New York City, Nashvillians felt justified with plans to replace the neighborhoods with more proper things, like parks or business buildings.

Similar to many of its sister cities, issues like Jim Crow plagued Nashville for decades. Jim Crow was a racial caste system that existed predominately in the southern portion of the United States from roughly the 1870s through the mid-1960s. This system included laws that restricted voting for blacks, limited access to public places and regulated how they could interact with white people. Beyond the laws, social customs of the era required Jim Crow etiquette that reinforced this racial hierarchy. Blacks did not dine with whites, blacks were not supposed to touch whites and so on. White Nashvillians tried to justify these actions by equating skin color with poverty and poverty with bad behavior.

Exposing these poor neighborhoods as the root of Nashville's crime just helped to distract from crimes happening elsewhere, especially when alcohol was involved. Solomon Cohn served as both a burr in the side of alcohol reformers as well as an example for their campaigns about the evils of alcohol. Sol owned multiple bars and taverns—his most prominent one in Black Bottom. His greatest immorality, according to newspapers of the time, was that he served people of color. This did not sit well with most of Nashville's white society. Nearly any newspaper report about the man mentioned how he catered to both whites and blacks. Having his business in Black Bottom made him a target for raids. One newspaper commented, "Raids on Cohn's place are of more than frequent occurrence."[64] Sol found himself in trouble often but paid his fines and continued his business

practices all the same. A ruthless man, Sol got himself into a fair amount of physical fights, landing himself in front of a judge because of his own actions multiple times. Proponents of prohibition used Sol as an evil example for alcohol—his involvement with the liquid made him wicked, so removing alcohol would also remove the wicked from him. However, once statewide prohibition was enacted, Sol went underground and became a well-known bootlegger.

Proponents of prohibition also used race as another argument for outlawing liquor entirely. During an especially vicious gubernatorial campaign in 1908, the prohibition platform argued that an "obscene label" of a gin bottle promoted criminal things, specifically among African Americans. The Reverend H.M. DuBose told the *Tennessean* about the bottles of Levy's gin: "This gin, with its label, has made more black rape fiends than all other agencies combined." Further articles by the *Tennessean* warned Nashville's women that they were not safe if these bottles remained on the shelves.[65] The Woman's Christian Temperance Union made such an outcry against the bottle that the city outlawed the sale or possession of Levy's gin.[66]

Debate raged about the true root of the immorality. What caused people to wander morally astray? Some opponents of the game tables claimed gambling as the "Evil of the Day" and the "Curse of This Town," arguing that those who partook in waging bets were easily tricked into other vices. The elegance of horse racing and billiards may seem harmless, but they opened doors to a sinful life. Still others argued that it was alcohol that led the way for sinners to start gambling. One 1899 editor claimed the "gilded décor" of saloons tricked good-natured people into doing deeds like gambling, as "Satan appears as an angel of light that he may the more effectually deceive."[67] This disguised "angel of light" deceived enough of Nashville's citizens that the temperance movement gained a fair amount of strength in response.

Alcohol has flowed freely throughout American history. Statistically, per capita,

While some fought the distribution of alcohol, others actively profited from it. The Gerst Brewing Company hosted the largest distributer of beer in the southeastern United States. *Courtesy of Nashville Metro Archives.*

84

Americans drank the equivalent of seven gallons of pure alcohol annually in 1830.[68] Tennessee dealt with this flow by enacting regulations to lesson access to alcohol and hosted some of the earliest temperance laws nationwide. Licenses for tax purposes were required when Tennessee became a state in 1796. In 1831, laws went into effect that required establishments serving alcohol to get a license from their county clerk. In 1838, the law changed to limit alcohol sold; the new Quart Law restricted sales of alcohol to one-quart containers or less.[69] The temperance movement continued to grow over the course of the later part of the nineteenth century both in Tennessee and across the nation. Tennessee's temperance efforts included founding the town of Harriman—a prohibition city specifically designed with the intention to prove that society functioned better when dry. In Nashville, arguments occurred about whether to tax this vice or restrict it. Regarding a new tippling law in the 1840s, a newspaper commented, "If money was required to meet the liabilities of the State, he was prepared to impose a tax upon his constituents; but he never could recognize the morality and policy of legalizing vice and immorality for the sake of raising revenue."[70] The argument whether to tax alcohol or restrict came to an end in 1909 when Tennessee established a statewide alcohol prohibition that would last until 1938.

Prohibition removed legal access to alcohol and created an entirely new illegal economy run by bootleggers. Alcohol never stopped flowing in the state—it just stopped flowing legally. In the state of Tennessee, moonshiners especially profited off of the nearly thirty-year statewide prohibition. One option for parties interested in obtaining liquor was to purchase from suppliers that existed in the surrounding wet states. The eastern Tennessee city of Bristol rested on the Tennessee-Virginia border. When Tennessee prohibition took effect in 1909, legal liquor suppliers moved their operations to the Virginia side of the border. The city's revenue from alcohol taxes went from $7,000 in 1908 to over $31,000 in 1909.[71] Nashville's location was not close to a border, but it rested at the intersection of two major highways. Rumrunners and bootleggers could import alcohol from another state covertly and drive it into the city. If that was not feasible, moonshiners would sell alcohol to bootleggers who would drive it in from semi-local locations. A Nashville citizen could easily obtain alcohol, if he or she knew the right people.

Electing the right people also helped Nashville's citizens gain easier access to liquor. In 1909, the city elected Hilary E. Howse as mayor. When he ran for office, he pledged that he would not enforce the statewide prohibition.

He proposed the question to Nashville voters in 1909: "Are you in favor of law enforcement—or are you in favor of a wide open town?" The voters answered by electing Howse. In 1912, he went against the statewide ban and reinstituted liquor licenses. He acknowledged that the citizens of Nashville widely ignored the ban. Saloon owners, bootleggers and their patrons needed Howse to stay in office in order to maintain the easy access to booze. At one point, when asked by reporters if he protected the saloons from prosecution, he replied "Protect them? I do better than that. I patronize 'em."[72]

Howse served as city mayor for twenty-one of the nearly thirty years of statewide prohibition. Even though alcohol was illegal, when he was in office, the access and lack of enforcement meant Nashville's citizens did not have to try hard to find a stiff drink. He also appealed to more than just the wealthy, white voters of the city. His political machine did not just stop with the liquor lobbyists. He campaigned for the poor votes of both black and white voters. Especially for the black voters, who had been discouraged from voting in the decades before, Howse offered positions that provided more for the community as a whole. During his 1909 campaign, he promised to improve parks and playgrounds and clean up Black Bottom. After he was elected mayor, he promoted voluntary cleanup days within the city, publicizing his visits to black neighborhoods in order to praise beautification efforts there. During his term, he promised better education, provided a new hospital and better access to clinics. His policies were the product of no articulate theory of government. "They were simply the response of genuine charity and shrewd politics…in the face of brutal conditions of poverty, disease, and discrimination in the inner city."[73] Because of his efforts drawing a large contingency of black voters, prohibitionists yet again found reasons to be upset with Howse. They claimed his party went to the saloons and dragged black voters to the polls. The *Nashville Banner* bemoaned Howse staying in office, arguing, "[Nashville] must continue to endure the evils of vice and disorder, believing that when the uttermost depths are reached there will be reaction…[that] must in the end bring better conditions."[74]

The prohibition in Nashville didn't make much difference in the amount of alcohol consumed by citizens. When enforced, prohibition did make a difference in prosecution and penalties. Nashville city leadership attempted to implement prohibition during the eras when Howse was not in office. Some of the public accused the police of allowing the "lawlessness" run rampant in the city. Clearly, not all of the public felt concern about the police enforcing the laws, as demand for liquor

remained high. From their pulpits, preachers condemned the public for consumption and the police for allowing the liquor to flow. This proved itself a heated and divisive era.

Solomon Cohn made grand, public overtures about leaving his illegal trade after a few years of being a known bootlegger. In 1914, Sol told newspapers he had quit the liquor business. "I just can't stand the pressure....[A]ll I ask is that you give me today to move out forty barrels of whiskey from one of my places and ship it back to Cincinnati."[75] The newspaper further reported that the sheriff believed that Cohn would be true to his word. He wasn't. Within a year, he was busted again for rumrunning. He never strayed far from his "King of Bootlegging" status. By 1917, he was boasting that he had made over $200,000 since the statewide prohibition took effect. Even as demand for alcohol drove the prices higher, Nashvillians still purchased the hooch. In his later years, one Nashvillian recalled, "Kentucky red brought $20 a quart....I remember, because I bought it."[76] Sol had supposedly left the business entirely by the early 1920s, but the stock market crash in 1929 ruined his legitimate finances. Soon he returned to the business he knew so well, and in 1935, police busted him for driving a car filled with liquor. His misdeed sent him to prison for five years. He was released within a year on parole. He died on April 30, 1939, and Nashville's prohibition ended on May 11, 1939. "His passing—literally—marked the end of an era."[77]

Nashville's bootlegging scene thrived even before the federal attempt at making the country dry. The style of alcohol varied from imported liquors from Canada to moonshine made in somebody's bathtub. The bootleggers also varied: "Nashville [had] bootleggers galore—'pocket' and 'wholesale'—including dapper 'gentlemen bootleggers,' a blind bootlegger, women bootleggers, and a giant man with rolled sleeves, dirty underwear, a big diamond, and '10 $1,000 bills in his watch pocket' (of which he was vastly proud.)"[78] Citizens of Nashville did not have to look very far to find the illegal substance.

Even as federal Prohibition took effect at midnight on June 30, 1919, Nashville's bootleggers stayed busy. The blockade runners already knew their worth and knew how to evade capture—usually. On the morning of the first day of nationwide Prohibition, Nashville police caught a Cadillac with an estimated $30,000 worth of liquor at the corner of Trinity Lane and Dickerson Road; the vehicle was bound for Nashville. The police reported another car escaped, and they could not say how many cars were in this bootlegging "train." The *Nashville Banner* reported, "[B]locade runners are

Federal agents dumping illegal liquor during one of their raids in Nashville. *Courtesy of Nashville Metro Archives.*

stepping on the throttles, bringing Barleycorn to a thirsty people. Moonshiners are still moonshining, bootleggers are still bootlegging, and the law is being enforced as effectively as can be expected." Prohibition as law of the land did not mean much for a state that had been dry for the previous ten years.[79]

Liquor regulations did not end with the repeal of Prohibition. As states and localities voted to bring back liquor, it slowly started to flow legally again. Nashville did not vote to allow alcohol until 1939, and even then, it did not allow liquor by the glass to be sold until 1966. Many counties statewide never voted to repeal Prohibition and remain dry even today. The fact that alcohol production and sales were still heavily regulated by state and federal agencies meant throughout the latter half of the twentieth century, agents would raid illegal stills from time to time.

8

EDWARD WARD CARMACK

*O*n November 9, 1908, the *Hawaiian Star* officially became the first newspaper to report about the shooting of former Tennessee senator Edward Ward Carmack. The story's entirety printed on the front page had only one line: "NASHVILLE, November 9,—Former Senator Carmack was today killed by Duncan Cooper and Robin Cooper in a triangular street shooting affair which was the outcome of political quarrels." The six-hour time delay meant Hawaiian islanders had a chance to read the story before it became national news. In middle Tennessee, the news of Carmack's death verbally echoed through nearby communities before local newspapers had a chance to get the story out in ink. The next morning, the story made headlines nationwide about how Duncan and Robin Cooper gunned down Senator Carmack. The gunfight on the corner of Seventh and Union Avenues would echo in many forms throughout Tennessee history. The consequences of this murder provided the state of Tennessee a new martyr while changing the social, cultural and legal understandings of liquor statewide for decades.

As the temperance and prohibitionist agenda began to grow in the nineteenth century, newspapers created their own alliances. Within the state of Tennessee, the *Nashville American*, the *Memphis Commercial-Appeal* and the *Chattanooga Times* newspapers published their opposition to prohibition. While liquor laws were passed in Tennessee, most outlined that local areas or municipalities made the decisions regarding liquor. Newspapers helped agendas for both sides of the prohibition argument. As the century progressed, prohibition became a political platform that candidates could not ignore.

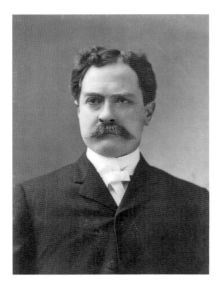

Edward Ward Carmack, from newspaper editor to politician, created many enemies in his career for the inflammatory things he said. *Library of Congress.*

Ida B. Wells, a journalist and civil rights activist, was run out of Tennessee by Carmack's calls for her lynching. *Library of Congress.*

Before Edward Ward Carmack died in the streets of Nashville, he worked in fields that held influence over public thought. Carmack served one term on the Tennessee General Assembly in 1884. Although he studied law, after leaving office, he pursued a career in journalism. In 1887, while writing for the *Nashville American*, Carmack "mercilessly ridiculed candidates of the Prohibition party."[80] As his career progressed, his journalism tactics fell into the category of wicked; he used his words to perpetuate hate crimes in the state. He endorsed white supremacy and the act of lynching. In his position as the editor of the *Memphis Commercial* newspaper, he publically called for the hanging of rights' activist and fellow journalist Ida B. Wells in 1892. Fearing for her life, Wells fled the state and did not return for over twenty years. He called for repealing the Fifteenth Amendment, which allowed black men the right to vote. In person, he charmed people and was "opulent in verbal extravaganza." During his campaigns, his physical appearance was often highlighted as a means to appeal to voters: "His thick shock of reddish brown hair shows mere suggestions of gray at the temples, his blunt mustache is untouched of time, and his steady blue eyes are clear and bright as a boys."[81] Since many of his views resonated with his readership, Carmack attracted many people to the polls.

In 1896, Edward Carmack usurped the incumbent Josiah Patterson and won the seat for the U.S. House of Representatives. It was a close election and resulted in damaged relationships between the two men. Carmack served two terms in the U.S. House of Representatives, and in 1901, he was elected to serve in the U.S. Senate. On the national issues, Carmack fought against American imperialism, business monopolies and equal rights for people of color. Carmack wrote that he was a "professional defender of Southernism," and many white audiences in the South supported his ideals. His view on alcohol proved moderate; he advocated for the regulation of liquor, not the ban. That remained his public understanding until he decided to run for governor of the state of Tennessee against a fellow Democrat. This fellow Democrat happened to be the son of Josiah Patterson, Carmack's foe from over a decade prior. If Carmack wanted to beat Malcolm Patterson, he would need to do something to set himself apart politically. Edward Carmack chose booze.

Until the gubernatorial primaries in 1908, Edward Carmack's political platform did not look too different from that of the incumbent governor, Malcolm Patterson. The issue Carmack decided to take up was liquor prohibition. He did not make his public claim until he was invited to debate Patterson in March 1908. Initially, prohibitionists thought it was a joke that Edward Carmack switched his views from temperance to prohibition. One editorial commented, "I have no complaint to make against Mr. Carmack on account of his sudden and miraculous conversion to State-wide prohibition….Some people are so uncharitable as to attribute his peculiarity to his desire to always be on the strongest side…but Mr. Carmack has not… admitted this to be true."[82] Newspapers did not take Carmack's new support of prohibition at face value initially. Some historians have argued that Carmack's "eventual embrace of the prohibitionist position was a matter of intellectual honesty." Maybe that is true. However, it isn't too much of a leap to suppose what the newspapers assumed—that Carmack wanted to win the election and this new prohibition support claim was the platform plank that could set him apart and help him find success. His true motivation for changing his mind from regulating alcohol to outlawing it entirely will remain buried with him.

The contest between the incumbent, Malcolm Patterson, and Edward Carmack heated up as the prohibitionists began backing Carmack. Patterson's campaign continued to support the regulation of alcohol but claimed a prohibitionist view was "undemocratic." Patterson's record reflected that he voted for temperance laws, stating that he had no intention

of repealing the temperance laws in place at that time. That was not enough, according to Carmack's campaign: "The saloon had sinned away its day of grace" and needed to be abolished. The primary election voter turnout broke records that year. Ultimately, Patterson won the primary election by over 6,400 popular votes and was reelected to the governorship.

Within weeks, Carmack turned back to his newspaper roots and became the editor-in-chief for the newly founded *Nashville Tennessean*. Founded by Colonel Luke Lea, the *Tennessean* advocated prohibition and proudly refused to publish any advertisements for alcohol.[83] In his opening editorial, Carmack made it clear that as editor he would ensure that under his watch, "The Tennessean [will] speak its mind freely and fearlessly with reference to conditions in our state politics."[84] Carmack used his position to write against Governor Patterson, the election and anyone who seemingly opposed Carmack.

By late October, Carmack's editorials became especially personal and filled with ridicule and vitriol against anybody he perceived as an enemy. In addition to mocking the governor, Carmack targeted men who had worked on Patterson's campaign, including his longtime friend and former mentor, Colonel Duncan Brown Cooper. Both men hailed from Colombia, Tennessee. Cooper owned the *Nashville American* newspaper when Carmack began his career as a writer there. Cooper likely advised young Carmack, being fourteen years Carmack's senior. They were both Democrats, and until he began working on Patterson's campaign, Cooper had supported Carmack throughout his political career. In his editorials, Carmack compared Cooper to the likes of Sol Cohn and Max Hartman, the "notoriously disreputable" saloon owners. For some elite, polite society, using these characters in comparison to Cooper seemed like a low blow. In addition to targeting Cooper's public honor, Carmack's 1908 editorials likely personally affected Cooper more because of how close these two had been in the previous decades.[85] Cooper's feelings evolved from hurt to anger.

Duncan Cooper made his fury about Carmack's scathing editorials known. After two days in a row of especially mocking editorials targeting Cooper, the aggrieved felt especially pained. Duncan made his threats so widely known that Governor Patterson called Duncan Cooper's son, Robin Cooper, to warn him to "stay with his father." The young attorney took heed of the governor's warning and borrowed a pistol from his uncle in case any threat turned true. As the father and son duo went about their business downtown on the afternoon of November 9, 1908, Carmack

returned to his apartment building on Seventh Avenue. His nosy neighbor, Mrs. Eastman, caught him just outside his building, seemingly cornered him and he remained in conversation with her for a few minutes.[86]

The moments that followed are filled with "what ifs." What if his neighbor had not stopped Carmack before he went inside his apartment? What if the Coopers, in an attempt to avoid Carmack, did not spend extra time at the Arcade and walked by earlier? Ultimately, the Coopers turned the corner on Union Avenue and saw Carmack standing in front of his apartment building. Initially, Robin attempted to distract his father, but Duncan saw Carmack and walked toward the former senator. Shakily, Colonel Cooper reached for his gun. Carmack reached for his own gun, and before anybody knew what was happening, shots echoed between the brick buildings. After the commotion, Carmack lay sprawled out on the sidewalk; Robin had a bullet in his arm but was still alive. Carmack had been shot four times, including at the base of his neck. He died before he reached the hospital.

What happened during this showdown emerged through various testimonies in a wildly publicized trial. Duncan Cooper's firearm remained loaded. After the shooting, it turned out that he had not fired any bullets during the fracas. Robin Cooper's firearm was empty—he fired all six of his shots. Carmack also emptied his chamber before succumbing to death. Both Coopers were found guilty of murder in a trial held in the following months. They appealed their verdict. Within a year, the appeals made it to the Tennessee Supreme Court. Yet again, a sensationalized trial echoed through newspapers nationwide. The supreme court reversed Duncan Cooper's verdict and upheld Robin Cooper's verdict. Feelings about the Coopers polarized those following the story even more than before. Each side believed the story about the shootout that suited them best.[87]

The prohibitionists found a new martyr for their cause in the deceased Edward Ward Carmack. His funeral, held in the Ryman Auditorium, had over seven thousand attendees. The *Nashville Tennessean* printed the eulogy given by Grantland Rice. Some of his lyrical language served as fuel for the prohibitionists in attendance:

The Chief is Fallen! But the Flag
in rippling roll
Waves proudly, let no Trooper lag
Of stalwart soul.

These stalwart souls made protests and inspired the state legislature to pass a statewide prohibition law that took effect on July 1, 1909. Depending on how you felt about the oncoming prohibition, the remaining wet days were either spent at church in thanksgiving or at the bar, saying farewell. The state may have made the decision to remove alcohol from the lives of its citizens, but not all citizens were in favor of this action. In Nashville, one response to the statewide prohibition arrived by way of voting in a mayor who promised not to enforce the prohibitionist laws in the city. Another response to the legislation came in the form of bootlegging. Liquor never stopped flowing in the Athens of the West.

In the years following his death, supporters of Carmack founded the Carmack Memorial Association of Tennessee and advocated for some form of statue to him. Fundraising came in donations from his old friends and supporters. In 1912, a young artist entered the nationwide contest—the grand prize for the winning submission was $10,000. "It was with surprise something like a shock that the American people learned that the rich prize had fallen to the lot of a girl just rounded into womanhood and wholly unknown to fame. She had done nothing previously except a few portrait busts."[88] Nancy Mai Cox-McCormack grew up in Nashville and had moved

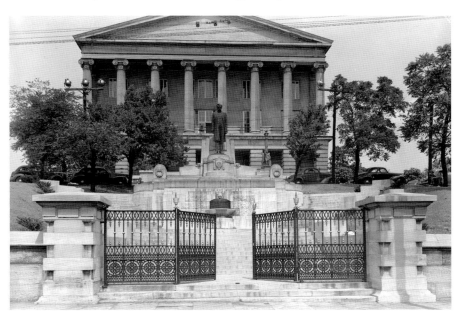

The Carmack statue was erected in 1925 in front of the Tennessee State Capitol. *Library of Congress.*

to Chicago to study sculpting. Her entry won the Carmack contest. Reflecting on her inspiration, she told a Chicago magazine, "I worked upon my model for the Carmack statue for six months. The idea of it was with me always. I thought of it during my waking hours. I dreamed of it at night. For that long period, it was my life—I lived my idea, consciously and subconsciously."[89] Cox-McCormack was commissioned to sculpt the piece in 1912, but the statue was not finalized until 1925. In that time, she went to Europe to study under other artists, including Auguste Rodin in Paris before he passed away in 1917. She sculpted the Carmack statue in Italy. While there, she got a commission to sculpt the bust of another controversial man, although she did not see it that way. Benito Mussolini commissioned her to sculpt his official bust. The *Nashville Tennessean* interviewed her about Carmack's statue and her Italian experience:

> *Mrs. Nancy Cox-McCormack, designer and sculptor of the Carmack memorial, gave some interesting accounts of her experience in Italy, where she did the actual work on the statue of Senator Carmack. Mrs. McCormack is a Nashville girl, who has won fame not only nationally, but internationally as a sculptor....One of Mrs. McCormack's works executed during her stay in Italy was a bronze bust on Benito Mussolini, dictator of Italy. A photograph of this bust which Mrs. McCormack showed the Tennessean reporter, clearly shows the Napoleonic features of Mussolini, and the determination and strength of the man to whom she believes Italy will one day build monuments as she has to all her great figures.[90]*

Mrs. McCormack was incorrect. Italy did not go on to build monuments of Benito Mussolini.

In June 1925, a dedication ceremony took place on the lawn of the Tennessee State Capitol. Edward Ward Carmack's martyr status for the prohibitionist movement was solidified in an eight-and-a-half-foot bronze statue that dedication day. In the main speech, Carmack was called "the crusader, marvelously-gifted editor, statesman and patriotic, versatile, genius and knightly gentleman." The orator continued waxing eloquent about Carmack, including making note about the location of his statue. "The fact that this statue occupies a site so commanding is in itself a high testimonial to the true nobility of the man whom we this day honor."[91] People gathered for the ceremony nodded in agreement as the speaker made note that Carmack was the reason for the now legally dry, moral state of their state.

The Motlow Tunnel under construction in 1958. *Courtesy of Nashville Metro Archives.*

The statue appeared to stare down at people who passed it. In 1957, the option to pass the statue changed when the state legislature voted to construct a tunnel leading into the state capitol building. Reagor Motlow originally presented the idea for the tunnel. His father was Lem Motlow, the nephew of the whiskey-distilling Jack Daniel. Construction on the tunnel began in 1958 and cost the state $1,800,000.[92] The new pedestrian

thoroughfare provided easier access to the building. Stories have since surfaced that the Motlow Tunnel's construction was a deliberate act to undermine the prohibitionist statue. Like Carmack's true intentions behind switching to a prohibitionist platform, the motivation behind the construction of the tunnel may never be known.

The statue of Edward Ward Carmack still stands in front of the Tennessee State Capitol building. While few onlookers know his history, he remains a faux-representation of the cause of liquor prohibition. The plaque attached to the statue neither mentions Carmack's political journey nor his support of prohibition. Entitled "Carmack's Pledge to the South," the poetry engraved on the plaque contains little substance. Carmack unintentionally found himself in a situation (albeit after death) that positioned his stone likeness prominently in front of the Tennessee State Capitol. Even though he served in political office during life, it was his death that triggered some of the biggest influences to the state of Tennessee.

9

A Bootlegging Love Triangle

*S*now scudded from the sky on a December evening in 1930, and workers at the Hadley Moseley Automobile shop on Broadway in Nashville went about their business as usual. The mechanics worked on a car while the stenographer, June Harley, typed away in her office. The owner and manager, John Hadley Moseley, stepped out of his office when his cousin announced someone was waiting for John outside. Moseley's most notable quirk, a tic, took place when he conversed with others; he was known for saying, "yes, yes," as a greeting or response. He stepped into the lobby, greeted with his traditional "yes, yes," as he approached the waiting figure. Recognition of the man radiated on John's face just as five shots blasted into him. Three bullets entered his torso, one hitting his heart. Richard Acklen ran from the scene. This seemingly simple murder with five eyewitnesses ballooned into a tale involving a high-society family, bootleggers claiming territory, an abusive husband, a lover's quarrel and yet another murder.

A snapshot of John Hadley Moseley's life showed a small piece of the American dream in 1930. A veteran of World War I, John had a wife, three children and a successful automobile business in Nashville. He owned his home on Colorado Avenue in West Nashville. Raised by a father who speculated for a living, Moseley drifted from home to home with his family until he was drafted to serve in the U.S. Army when he was twenty-four years old. During his service in the military, he received the Distinguished Service Cross and the *Croix de Guerre*. Upon his return from the war, he traveled with his family to find work. He soon married Mary Boyle, a seventeen-year-old farm girl from Dickson, Tennessee, and they settled in Nashville.[93]

Before his work in the automobile industry, John owned a sandwich shop in Nashville. Where he got his capital to start his own business is unknown, although it is easy to speculate that it came from his involvement in bootlegging. Throughout the early 1920s, Moseley was arrested several times for his involvement in the liquor trade. His lawyers were known to physically present Moseley's war medals as a means to show his character and past good deeds. He served time in jail and insisted that his time in jail set him straight. In 1926, he was charged with selling whiskey at his sandwich shop. He claimed his innocence and that he was "leading an exemplary life conducting a legal restaurant business." The business ran late hours to accommodate college students and late-night dances; John argued that the late hours should not be held against him. The judge dropped the federal charges.[94]

Within two years, Moseley began working at a car sales business on Broadway. Sandwich making may not have been able to pay bills, and Moseley seemed adept at selling cars. After a year of working at the automobile shop, Moseley became manager. He took over as owner in January 1930. His entanglements with the bootlegging crowds never left him, however. An automobile shop served as an excellent front for a bootlegger. Liquor could come and go under the guise of automobiles. The shop could easily work on cars while mechanics actually outfitted the vehicles with illegal booze. During the late 1920s, Moseley seemed to stay under the authorities' radar until his deadly encounter with Richard Acklen.

Richard Acklen grew up in one of the most prominent families in Nashville. His grandfather Joseph Acklen married a wealthy widow named Adelicia. Her estate left by her first husband was valued at $750,000 when she remarried—an estimated $24 billion today. She spent part of her time in Nashville and part of her time in Louisiana, where she had over 8,700 acres of cotton plantations. Some of her early estate included 750 enslaved workers—the wealthiest woman in Tennessee had influence over many lives in many ways. Her son, Colonel Joseph Hayes Acklen, studied law abroad before serving both in the Louisiana state militia and in the U.S. House of Representatives for the state of Louisiana. He returned to Nashville in 1885 to continue practicing law. He became one of Nashville's most prominent lawyers. In 1890, he married nineteen-year-old Jeanette Tillotson from Kansas City, Missouri. She bore eight of his children, although only three survived to adulthood. Their son, Richard, technically reached adulthood but died of a gunshot wound when he was twenty-two years old.

Acklen Death Sequel to December Slaying

A cast of players in a murder mystery case that captivated nationwide audiences in 1930. *From the* Nashville Tennessean, *May 10, 1931.*

The young Richard did not show much interest in following in his lawyer father's footsteps. He graduated from Hume-Fogg High School in 1928 and attended Vanderbilt for one year. Active in his fraternity, he went to dances and socials. He left school after that year and began working for the local *Nashville Banner* newspaper as a police reporter. For a while, he contributed to the *Evening Tennessean* in the same capacity. As a wealthy scion, he could afford to drift from one activity to another. By the end of 1930, he had moved out of his parents' house and into an apartment he shared with his brother on Twenty-Fourth Avenue South in Nashville. Was he seeking freedom from his parents, or did his parents encourage him to find his own place? Did Acklen's parents suspect his activities were not all lawful? Sometime between writing about criminals for the newspaper and then becoming his own headline by shooting Moseley, Acklen got involved in the illegal liquor trade.

John Hadley Moseley pleaded "not guilty" to possession or trafficking of liquor in the courts when charged in the 1920s, but clearly he had the means and motives to distribute alcohol. Prohibition in Tennessee began as early as 1909 when a statewide ban took effect that forbade the sale of liquor within four miles of any school in the state. Soon after, another law outlawing the manufacture of alcohol in the state took effect. However, authorities in Tennessee cities like Nashville did little to enforce these laws. With such a lax approach to the illegal activities in Nashville, citizens could get involved in the lucrative trade with little fear of getting caught. Rumors swirled about how the police and local leadership partnered with bootleggers for their own profit. Moseley served time in jail for his early illegal liquor activities and even though he

boasted that his involvement with bootleggers was over, he still recruited Richard Acklen to run liquor for him.

Did Richard get involved with bootleggers while he worked as a police reporter? Whether his involvement started during or after his short-lived career as a newspaper reporter, he began working for John. Later, after Richard's death, one newspaper speculated that he was actually working undercover to write an exposé about bootleggers. There is no evidence to support that claim, although it made a good story (and helped sell newspapers). Richard was likely just a young man who wanted the fast money or the adventure of rumrunning. Sometime in July, Richard found himself in a tight spot, and John offered to help him out. When Richard spent the night at the Moseley residence, he met John's wife, Mary. Her cherub face and brown eyes captivated Richard, and he took a liking to Mary. They quickly became more than just friends. Their budding affair pushed Acklen to do the unthinkable act and take the life of another man.

As Richard got more involved with Mary, he branched out and began running his own liquor trafficking business. Growing his own liquor business proved easy for Richard, likely having known local law enforcement from his reporting days. He was the son of an elite Nashville family, the grandson of one of the most powerful women of her time. What would police do to him, especially if they weren't enforcing liquor laws consistently? Richard's own ventures did not sit well with John. In addition to the rumors that Richard was developing a competing liquor trade, word got around that Mary and Richard were seen "riding" together, sometimes in daylight. Richard didn't shy away from his relationship with the married woman, flaunting it to his friends and family. By his own account, he was willing to "give up his parents" (and their money) for this extramarital relationship. Richard's flaunting around town meant that his former business associate turned rival noticed, too.

The night before the shooting, two officers showed up at Richard Acklen's apartment. Stories differ regarding exactly what happened in the hours that ensued. The officers stated that another citizen accused Richard Acklen of being a wanted man with a reward over his head, so they arrested Acklen. One account indicated he went willingly; another account described that the officers gave Acklen little choice. Officers John Davis and L.D. Borum drove Acklen to the corner of Sixteenth Avenue and Broadway. When they arrived at the meeting point, Richard saw a figure get out of another car and walk toward Richard.

A solid blow landed on Richard's jaw while he was still seated in the police vehicle. John Hadley Moseley had been the one who tasked the

officers with bringing Acklen to him and threw a punch without warning. Moseley's secretary, June Harley, later identified the officers as having had a conversation with John in his office just before this encounter. After the punch, one of the officers stepped in to hold John back. "You'll be a dead…by Saturday night!" Moseley threatened Acklen. (What profane language Moseley used must be left to the imagination, as it was terrible enough that the newspapers could not print it.) With a throbbing jaw and a wounded ego, Richard left with the officers and returned to his apartment. The police officers were later suspended for their activities, charged with "conduct unbecoming an officer." They claimed they were just doing their job by looking for a suspect and had "gotten the wrong man." After their own trial, both officers were fired for their actions and involvement with a known bootlegger.

The next day, John called one of Mary's friends, Myrtle Chandler, early in the morning to help him look for Mary. He relayed a sad story about how Mary just left him in the night with their children and didn't tell him where she was going. Myrtle felt it was her duty to help save this marriage. John gave Myrtle a list of potential addresses where Mary might have found sanctuary. The first address listed was that of Richard Acklen. Chandler went to the apartment. While she found nobody in the building, she did notice tracks of different sizes, including those of two children. Did Mary Moseley spend the night with Acklen? Mrs. Myrtle Chandler didn't want to speculate on such sensational things, of course. Myrtle found Mary and the children at the next house on the list, one belonging to Mary's aunt. She got a friend to take care of the Moseley children for the day and tried to cheer Mary up. They returned to the Moseley house with the intention of getting ready for a trip downtown to take their mind off of events. Within an hour of being there, Myrtle discovered Mary in a closed room with all the gas vents open.

"Mary, what in the world are you trying to do?" asked an exasperated Chandler.

Mary answered in a defeated voice, "I'm tired of this, and I am going to end it all." Myrtle opened the windows, aired out the room and coaxed Mary into taking the ride to downtown as they had originally planned, undoubtedly using the enticement of fresh air doing some good. The two of them made a stop at the Moseley Motor Company to visit John. In her attempt to help the Moseleys, Myrtle asked John if he would make up to Mary. According to Myrtle's account, "He replied, smiling, that his wife was going to leave town." He said everything was "fixed up." Moseley told the ladies to pick him up around 8:10 p.m.; he would be done with

work and ready to eat then. The women left to go downtown, unaware that they were seeing him for the last time as they waved goodbye.

At one of their first stops downtown, Mary Moseley made a phone call from a pay phone. Within a few minutes, Richard Acklen met the women, and the three began driving around. While Myrtle admonished the couple's trysts, she still rode with them. During this afternoon ride, a fresh scar on the cherubic cheek of Mary Moseley caught young Acklen's eye. She related that her marriage had not been very good, and Moseley left the evidence on her cheek the night before. "Nothing but a coward would do that!" he told her. Having felt Moseley's own fist just the evening prior, Acklen's blood boiled. Did the women share with him the events that had taken place just hours prior? Did the attempted suicide add to Acklen's rage? The two women dropped Acklen off at his apartment on West End and rode back to the Moseleys' residence. Myrtle continued her meddling work of encouraging the Moseleys to stay together and make their marriage work. John Moseley had asked that favor of her just hours before. When she saw her friend's scar, Myrtle defended Mr. Moseley's domestic abuse by claiming "love could cause lots of things." Between a friend who wouldn't listen and an abusive husband, Mary felt she had no choice but to leave town.

At 7:45 p.m. that snowy night, Richard Acklen walked into the outer office of Moseley Auto Company and asked for John Hadley Moseley. John's cousin, Sterling Moseley, shouted out to John that he had company. An automobile shop, sales company and likely a site for some of Moseley's illegal liquor business, the place had all sorts of patrons coming and going. John would have had plenty of reasons to come out and see what type of patron was waiting for him without fear. Moseley stepped into the outer office with his customary "yes, yes," and five blasts rang out. The commotion caught the attention of several employees; the secretary thought somebody set off fireworks in the building. Acklen ran out of the building and turned up Broadway. Three employees attempted to chase Acklen on foot but could not catch him. Another two employees saw him and identified him to the police.

The police found Acklen in his apartment on West End. The arresting officers were none other than the two who had picked him up the night before, John Davis and L.D. Borum. When the police first arrested him, Acklen maintained his innocence. He had ticket stubs to a movie and insisted that was where he spent his evening. The officers took Acklen to the city jail downtown where assistant chief of detectives Bate Winfrey met the group. Several police officers questioned Acklen until Richard's

father—and attorney—Colonel Joseph Acklen came down to the jail to counsel his son.

Early Saturday morning, as Acklen still maintained his innocence, investigators began putting together a story about bootlegging violence. John Hadley Moseley was a known bootlegger. Richard Acklen admitted to receiving his own batch of Christmas liquor for distribution, going against his former employer. The early morning edition of the *Tennessean* made note to include Moseley's war efforts and his illegal business history. "[R]umblings of an even deeper plot were rolling about, and it was said that they might result in revelations regarding 'turnings up' in federal court. It is known that bootleggers had been zealous and jealous over the whiskey trade." Citing a story it covered about him many years prior, the newspaper quoted John: "I don't know why I became a bootlegger, unless it is that I can't stay away from excitement. When things get quiet, I get restless." If a bootlegger murder mystery sold newspapers, what happened when reporters tossed in an extramarital affair to the speculation and circulation?

By the end of the day on December 20, details emerged to the police and local reporters about the love triangle between John Hadley Moseley, Mary Moseley and Richard Acklen. Young Acklen changed his story from one of innocence to one of self-defense. He told of Moseley's threats against him and stated that he saw Moseley reach for what he believed to be a gun, so Acklen fired first to protect himself. He was released on a $15,000 bond, signed by his father. Acklen would not talk about his affair with Mary Moseley. He did not have to, however. Myrtle Chandler, the friend so willing to help the Moseley marriage two days prior, was full of information and ready to share with the equally eager newspaper reporters. She regaled the reporters with the story about the love affair and how Mary confessed that she loved Richard. Myrtle shared all of her opinions on the matter, including how she felt about John hitting Mary as a reaction to his "love for her."

The juicy story combining a high-society family "whose history can be traced back to Revolutionary days," a known bootlegger and a love affair captivated readers. The *Tennessean* ran an obituary practically hailing the bootlegging Moseley as a fallen hero: "To the members of the profession in which he engaged after coming home, who also will be present to honor him, they will be burying a 'good guy.' As a liquor vender in Nashville he gained the reputation of a man who, although working a racket against the law, kept his promise, and played the game straight." Painting a scene in which the deceased looked good and the accused murderer looked bad made for a tantalizing tale.

In early January, the criminal court set a trial date for Richard Acklen for May 15, 1931. Six days prior to the trial date, Richard Acklen was shot in the head. The Sunday morning edition of the *Nashville Tennessean* reported, "Richard Acklen presumably cheated the law of its chance to pass judgment on his killing of Hadley Moseley, king bootlegger, when he is declared to have turned a pistol to his head while keeping a tryst with pretty Mrs. Moseley, widow of the man he killed." The initial reports claimed suicide. Police investigators said there was "no doubt" Acklen took his own life. The bullet wound was on the right side of Acklen's head, above the right ear.

Acklen's death occurred at the Moseley residence on Colorado Avenue in West Nashville. Mary Moseley called the police, Richard's father and then the hospital, reportedly in that order. As 911 did not exist until 1968, Mary did not have a particularly easy way to call for and receive assistance after discovering his body. Colonel Acklen arrived first, followed by police investigators. Police noted that the gun rested on a chair in the room where Acklen laid, barely hanging on for his life. They also noted that a friend of Mrs. Moseley, Eva Ingram, and Mrs. Moseley's eight-year-old son were also present in the house during the shooting.

Mrs. Moseley rode in the back of the ambulance as its sirens cleared traffic in an attempt to get Acklen to the St. Thomas Hospital in time to save his life. He died en route and was officially declared dead within two minutes of his arrival to the hospital. The police investigators met the widow Moseley at the hospital to take her statement. According to her, Acklen had been worried about the upcoming trial. She stated that while she was in another room, she heard a gunshot from the back room. Mary ran to the sound, only to discover Acklen laying in a pool of his own blood. One police officer made note that "she was awfully broken up over it."[95]

On the Monday after the death, state investigator Ted Vaughn made the announcement that he intended to "gather details" about the suicide and question Mary Moseley in the matter. He did not give a reason for the additional investigation efforts. The reporting police and Colonel Acklen agreed that the young man died from suicide. Mary Moseley refused to answer further questions. Mrs. Ingram had also reportedly left town. It turned out that Mrs. Ingram was a wife of another convicted bootlegger and hijacker of Nashville. On the Friday following Richard's death, a fire burned through Mary's apartment, completely destroying the room where Acklen had been shot. The firefighters reported that nobody was home and the fire seemed to have originated in the closet. Investigations continued.

An investigator shows the burnt remains of the room where Acklen was shot. The inset image on the bottom left of this newspaper image shows the bullets used as evidence in the trial. The middle bullet was the one that shot Richard Acklen. *From the* Nashville Tennessean, *June 3, 1931.*

On June 1, Jeanette Acklen, Richard's mother, tasked a "secret inquest" at the tomb of Richard Acklen in Mount Olivet Cemetery. A coroner's jury was made up of seven members of the jury and two physicians. The physicians examined the body and claimed that the bullet wound did not suggest suicide. Their findings revealed that the hole was actually two inches above the ear and one inch behind the ear. They assessed that the angle of the bullet was downward and could not have been fired by Acklen himself. The *Nashville Tennessean* reported the next day that the members of the inquest were sworn to secrecy and could not reveal their identities. With this new information about the bullet wound, investigators changed their approach from a suicide to a murder.[96]

The next day, "after a spirited search," the investigators found Eva Ingram, or more accurately, she found them. She had read they were looking for her and just walked into the police headquarters. Her testimony reflected that of a suicide. Mrs. Ingram relayed that she heard Mary and Richard arguing, but

Mary Moseley and Eva Ingram leaving the courthouse after the first day of their murder trial. *From the* Nashville Tennessean, *December 15, 1931.*

they argued often. She was sitting in the front room with young Hadley Moseley Jr., as he was recovering from measles. Eva heard a shot from the back of the house and a scream from Mary. Eva ran to the back bedroom and found Mary trying to drag Richard; she reported that she calmed Mary down, and they made calls to the police and ambulance. When she saw the .38-caliber pistol sitting on the chair, Eva asked Mary how it got there. Mary confessed she must have picked up the gun from the floor and put it on the chair. Eva's two sons were outside and also reported that they heard a shot and a scream. The scene appeared to be one of suicide.

During the weeks that followed, different theories evolved around Richard Acklen's death. One theory emerged that John Hadley Moseley had ties to Al Capone's gang and John had paid "protection money." With this theory, investigators speculated that Richard Acklen shooting John Moseley meant a boss from Capone's gang needed to take out Acklen in retribution. Richard's defense lawyers even reported that he had purchased a gun about two months prior because of some threats he had received scrawled out on notepaper. The fire that burned the crime scene seemed to point toward fellow bootleggers as suspects. Another theory surfaced that Richard had intentions of using his former life as a reporter to expose the underground bootlegging world. That theory conjectured that Richard was murdered to protect the illegal bootlegging trade. The story made national news, and papers as far away as California were publishing front page headlines about Richard Acklen's death.

While the newspapers thought that the crime syndication murder made for a good story, ultimately testimony from Mary Moseley's eight-year-old-son contributed most to the investigators' inquiry and discovery about the murder. D.G. Moseley, John Hadley Moseley's father, received custody of

the Moseley children. When he came to Nashville to retrieve the children, he and police discovered that Mary had fled Nashville for Washington, D.C., with her children to stay with her sister. The state investigator escorted D.G. Moseley to Washington, D.C., in order to enforce the custody ruling. They found Mrs. Moseley, took the children and headed back to Nashville. Supposedly on the train ride back to Nashville, young Hadley Moseley Jr. had a startling testimony. Hadley Jr. told the state investigator that his mother had coached him on what to tell the police. Hadley Jr. continued his testimony by telling the state investigator that he heard "scuffling" before the gunshot and the argument between Richard and his mother became violent.

This new piece of information ignited a flurry of investigative action. The police and the district attorney brought Hadley Moseley Jr. in for further questioning. Jeanette Acklen was also present, although the reason why she was invited remains unclear. The boy told his small audience that he saw the fight take place. He reported that the fight got physical, and his mother hit Richard. "She wore lots of rings," he told the police, evidently explaining some of the cuts and bruises that were later discovered on Richard's face. As the fight got heated, the boy said he was "so ashamed [that] I turned my head to keep from seeing it." He heard the shot and confessed his mother had killed Acklen. After Richard Acklen's mother heard the boy's testimony, she swore out two warrants for the arrests of Mary Moseley and Eva Ingram.

Eva Ingram was arrested first, and the police went to Washington, D.C., to arrest Mary Moseley. Eva's testimony did not change; she claimed she only heard what went on between Richard and Mary and could not say if it were a murder or a suicide. Sol Cohn, a former saloonkeeper and purported bootlegger, paid her bail. District of Colombia police picked up Mary Moseley in the early hours of July 4, 1931. State investigator Ted Vaughn made a second trip to Washington, D.C., to escort Moseley back to Nashville. On July 7, the grand jury in Nashville indicted both women for the murder of Richard Acklen based on the testimony of an eight-year-old boy.[97]

On a sunny, breezy day in mid-December, crowds of the tantalized Nashville public forced the murder trials of Mary Moseley and Eva Ingram to be held in a larger courtroom. The jury was selected on December 14; the trials began on December 15. Jeanette Tillotson Acklen, Richard's mother, testified first. Her husband, Colonel Joseph Hayes Acklen, followed on the witness stand. Adding to the anticipated drama, Colonel Acklen had to be wheeled into the courtroom on a reclining wheelchair, as he had broken a hip a few months prior. Both relayed how their son just got mixed up in the

wrong crowd. Just as the prosecution called Hadley Moseley Jr. to the stand, one of the lawyers quit mid-trial. Jack Norman, attorney for the prosecution, exclaimed he "wouldn't take part in a murder trial wherein a boy of nine testifies against his mother." District Attorney Richard M. Atkinson remained unfazed, as the public continued to reel with excitement over the courtroom drama. Jeff McCarn, the women's defense lawyer, objected to the boy as a witness. The judge overruled him.

The next day, young Hadley Moseley Jr. took the stand. The *Tennessean* reported, "Testimony of the child threw a net of circumstantial evidence around his mother and Mrs. Ingram. He witnessed a scuffle between his mother and young Acklen, which was stopped by Mrs. Ingram just five or 10 minutes before firing of the shot." He relayed a story of scuffling, arguing and a shot being fired. He testified that he ran to the back room and saw his mother leaning over Richard Acklen's body. "I told the police when they arrived that Dick killed himself because Mrs. Ingram told me to tell them that," he concluded.

Later in the day, the physicians who led the coroner's jury testified to Richard's gunshot wounds. Coroner J.R. Allen and Dr. H.B. Parrish agreed with each other that the young man had wounds all over his body, the bullet's path did not point to suicide and powder burns were missing from Richard's hand and head. As Dr. Parrish spoke, portions of Richard's hair were passed around the jury as evidence that it lacked gunpowder residue or burns. He explained that evidence of burning would occur if the shot were fired at least twelve inches from Richard's head. No burns prove that it was impossible for the young man to have held the gun himself. When the defense asked for the evidence of the gun, the prosecution scrambled. Somewhere between the crime scene and the courtroom, a valuable piece of evidence had disappeared.

The doctor's testimony regarding Acklen's wounds swung the pendulum of doubt in one direction until the next morning, when the defense called up B.E. Raines, the ambulance driver on that fateful May day. Raines stated that Colonel Acklen stood over his dead son's body at the hospital and said, "Son, what did you do that for. You told me you were going to do it, to save the family from disgrace, but you didn't have to do that." The prosecution submitted a sworn statement from Colonel Acklen—at that point too ill to leave his house—denying he ever said those words. The drama playing out in the courtroom kept the public benches packed.

The women charged with murder, Mary and Eva, took the stand next. When Mary spoke, she had the attention of everyone in the courtroom.

What would this bootlegger's-wife-turned-mistress say? She calmly spoke through most of her story, recounting how she committed adultery but wanted to make amends with her husband. She testified that Richard Acklen asked her to divorce her husband and marry him. Mary declined. "I loved Dick," she exclaimed to the jury. Mary had told Richard that she was going back to her husband to reconcile on the night her husband was shot. Teary-eyed Mary continued that on the day Richard died, he invited her to go out with friends. She declined, wanting to visit her husband's grave. This mention of her husband provoked Richard, she said. He got angry, and they had an argument. She left the room and heard the shot.

Mary's testimony continued with how she didn't remember even seeing a gun in the room. She tried to move Richard's body to help him and decided to call an ambulance to see if they could help. Eva's son ran in from the back to help Mary move Richard. When the ambulance arrived, Mary rode with Richard to the hospital. She knew he was dead before the doctors made their proclamation.

During the cross-examination, Mary admitted to having cancelled checks that her husband paid to local leadership and law enforcement, supposedly for protection. Atkinson began to ask about these checks when McCarn objected. "When the proper time comes for an investigation along that line, we will give more evidence along that line than the prosecution wants!" he shouted. District Attorney Atkinson yelled back, "I want the court to know that I want it all!" After this minor exchange, the judge sustained the objections at that time.

The final witness called was Eva. As little evidence showed Eva's involvement in the events from May 9, the court acquitted her two days into the trial. She still had to testify. Her story corroborated what Mrs. Moseley had said. Eva was in the house when she heard an argument and a shot. When she saw Richard's body, she ran out back yelling "Dick Acklen's dead! Dick Acklen's dead!" Her son, who was working in the backyard, ran in to assist. Eva had little else to say beyond her story.

The attorneys made their closing arguments. The prosecution argued that somebody had killed Richard Acklen "It was this woman," Atkinson proclaimed, "this defendant who never sheds a tear; this sphinx like woman it was whose manner of life has hurled two souls unprepared into eternity!" The defense asked for forgiveness: "We have tried her on bootlegging and adultery charges here instead of the murder charge on which she stands indicted." The jury had their decision the next morning. All twelve jurors found Mary not guilty of murder in the first degree. Before the

judge finalized the trial, he drew attention back to those cancelled checks supposedly buying public officials.[98]

After her acquittal, the press asked Mary Moseley what was she going to do now that she was a free woman? "I don't know," she answered. She drifted into the lost pages of history, as no records exist of her after the trial. An aunt and uncle took in her children when their grandparents passed away. Jeanette Tillotson Acklen continued her crusade against the "lax discipline of the Nashville police department."[99] For months, she wrote letters to the police department, mayor's office and even the governor of Tennessee, seeking justice for her son's death. Colonel Joseph Acklen passed away a few years later. Did Richard Acklen take his own life? Or did Eva murder him? The truth is buried with them. What served as the story of the year now rests as a piece of Nashville's past.

Epilogue

NASHVILLE'S VIRTUE

In a short summary, whiskey inspired Nashville's most iconic building (and possibly the most iconic building in country music): the Ryman Auditorium. Now often billed as "The Mother Church of Country Music," the tower of bricks adorned with colorful stained glass became a world-renowned stage in the later part of the twentieth century. Its beginnings, however, are rooted in a fiery preacher who preached against the evils of things like dancing, baseball and, of course, liquor.

Samuel Porter Jones traveled and preached. In part due to his own struggles with alcohol as a young adult, Sam Jones's passionate sermons often highlighted the evils of the drink. When Jones visited Nashville, he would do so for twenty-one days at a time, hosting essentially a three-week evangelical revival meeting. While in Nashville, he claimed, "Every barroom is a recruiting office for hell!" Nashville had plenty of barrooms and a population ready for the stirring message Jones brought with him. People in the city believed his efforts were working within the city, and that reputation began to grow in other cities, too. A book of his published sermons printed in 1886 wrote about Nashville: "The churches [in Nashville] have been quickened with a higher, purer and holier life, and theater-going, card-playing and drinking have been largely diminished. He had never in his history known of a religious work anywhere that was so deep and thorough and permanent in its results.... The golden opinions which he had won at Nashville followed him everywhere." These golden opinions helped Jones's evangelical movement and encouraged some people to change their sinful ways.[100]

Captain Thomas Ryman felt especially moved by Sam's powerful talks. While Ryman's life is shrouded with legends, there remain a few verifiable understandings about the man. Thomas Ryman was a steamboat captain who attended one of Jones's revival meetings in the 1880s. Different versions of Ryman's transformation experience exist. While some told a story of Ryman arriving to the meeting drunk, others swore he never got drunk in his whole life. For dramatic effect, the story of a stumbling drunk who encouraged drinking only to find his salvation at a revival meeting seemed more meaningful than a teetotaler who found somebody who agreed with him. Regardless of his state of sobriety at the meeting, Sam Jones provoked Thomas Ryman in a way that inspired the steamboat captain to build a grand structure for revivals. It took him a few years, but by 1892, he had seen his vision come to fruition. Ryman's Union Gospel Tabernacle stood as a nondenominational church for traveling preachers like Sam Jones.

Legend of Thomas Ryman's initial reaction to the revival meeting has permeated many of Nashville's stories. Ryman owned a steamboat and shipping company that operated along the Cumberland and Ohio Rivers. Legend states that the reformed Ryman, with his newly reformed friends, gathered the whiskey barrels from his saloon and poured the liquid into the Cumberland River. This story continues with Ryman sending word to his company's riverboats to do the same. Thomas Ryman may have been moved to eliminate liquor in his business dealings, but he likely did not dump out the merchandise. Concessionaires operated the food and drink side of business aboard his ships. Ryman likely just allowed the concessionaire contracts to expire. He met with Sam Jones during Jones's stay in the city, and the two discussed plans for further spreading the good news.

While Ryman wanted to build a "a tabernacle for all denominations," the Young Men's Christian Association's building campaign remained Jones's focus at that time. Thomas invested in a smaller building on Broad in 1886. He also paid for "scripture boards" posted around town, as well as a gospel wagon within the city. Ryman's gospel wagon became a fixture of Nashville for decades. Sermons could be preached anywhere in the city. Having a mobile church service, the preacher could target specific neighborhoods. During the gospel wagon's visit to the men's district by the Maxwell House Hotel in 1901, the preacher's voice boomed over crowds as he discouraged their evil ways. "Some of you have lived long enough to be blamed fools, and if you don't stop your devilment soon you will be in hell and be damned

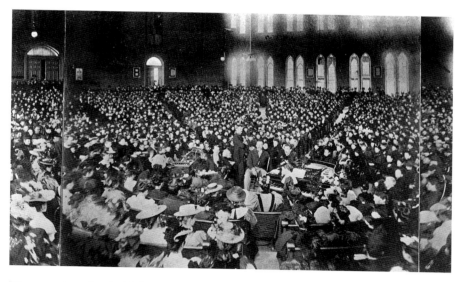

Women gathered at the Union Gospel Tabernacle to hear Reverend Samuel P. Jones speak. Reverend Jones is speaking in the middle of the auditorium. *Courtesy of the Tennessee State Library and Archives.*

fools....There are about 1,000 two-legged dogs in a few blocks of this Maxwell House that haven't sense enough to quit chasing shadows." Some laughed in amusement at this, and still others came up to the wagon at the end of the sermon and "promised to be good."[101]

Thomas Ryman saw his idea for a tabernacle to accommodate multitudes come to fruition in 1890. The charter for the new Union Gospel Tabernacle was filed on February 25, 1889, and the members of the charter began construction that summer. The first revival meeting held at this new building in May 1890 took place before the building's completion. Completing Union Gospel Tabernacle became an obsession, and he went into debt to help fund the building.

Early in the building's history, it served as a nondenominational center for religious meetings. Famous theologians and preachers visited and packed the house. Samuel Porter Jones visited on fundraising tours at least once a year. When Christian evangelist D.L. Moody visited in 1896, he packed the house for his two-week visit. Thomas Ryman intended the building to remain one for religious activities alone, but the debt the building had incurred smothered his desires. The trustees allowed the building to host other public events. Ryman insisted that nothing morally reprehensible should ever occur in the building but succumbed to the building's opening to secular activities.

Initial events included things like political speeches, opera shows and a site for civic groups to use for meetings. Thomas Ryman, in declining health in the years preceding his death, passed away in 1904. Sam Jones spoke at Ryman's funeral and at the end of his sermon offered the suggestion that the city rename the building after Thomas. During his lifetime, Ryman refused this name change. Mourners at his funeral expressed their feelings about changing the name by rising to their feet and thunderously applauding at the idea. Even though the building's trustees did not officially change the name until 1944, locals began using the new name of "Ryman Auditorium" soon after Thomas Ryman's passing.

One of the more influential people to utilize and promote the Ryman Auditorium was a fierce, sharp-tongued woman named Lula C. Naff. She began her career working for a booking agency, the Delong Rice Lyceum Bureau. The agency booked talent for the Ryman Auditorium until it dissolved in 1914. Lula worked independently at that point rather than find another job. She loved the building and hustled to get a variety of acts to perform there. Her efforts convinced the board to hire her as the building's manager in 1920.

As Lula worked to draw musical acts and theater productions to the Ryman Auditorium, a radio broadcast formed in 1925 that would have major implications for the city of Nashville. The National Life and Accident Insurance Company launched the new radio station with the call letters "WSM" for its motto, "We Shield Millions." By the end of the year, a regularly featured program played barn dancing music, the show that would eventually get the name *Grand Old Opry*. The *Opry* show began drawing fans, and it needed a larger venue to host these fans. It had a few homes, including the War Memorial Auditorium, but eventually settled at the Ryman Auditorium in 1943. Lula Naff did not appreciate the show's style, but it drew revenue so she could not argue with hosting it at the Ryman

Before becoming the home of the *Grand Ole Opry*, the Ryman Auditorium served as a church for fiery preachers like Sam P. Jones. *Library of Congress.*

116

Auditorium. In the same year that the *Opry* found a new home at the Ryman Auditorium, the show received new sponsorship, and NBC began airing it on its affiliate stations. The Ryman name, and country music, could now be heard nationwide. These events served as early beginnings of country music's popularity. The show also gave the nation a reason to associate country music with Nashville. As country music grew in popularity, so did Nashville's reputation of being "Music City."

Without Nashville's vice being such a concern in polite, Victorian society, there may not have been such an effort to encourage virtue. Revival meetings may not have had as much influence, and Thomas Ryman might not have been so moved to build his tabernacle. The Ryman Auditorium played an influential role in the development of country music; it is hard to imagine what the musical genre would look like without the tower of bricks on Fifth Avenue. Embracing Nashville's notoriously rowdy past allows us to appreciate its musical and cultural present.

NOTES

Chapter 1

1. Paul Clements, *Chronicles of the Cumberland Settlements 1889–1796* (Nashville, TN: Self-published, 2012), 74–75; John Wooldridge, *History of Nashville, Tennessee* (Nashville, TN: Publishing House of the Methodist Episcopal Church, 1890), 38; W. Woodford Clayton, *History of Davidson County, Tennessee* (Philadelphia: J.W. Lewis and Company, 1880), 195.
2. Clements, *Chronicles of the Cumberland Settlements*, 75.
3. Ibid, 103.
4. Ibid.
5. Clayton, *History of Davidson County*, 84; Wooldridge, *History of Nashville*, 88.
6. Clements, *Chronicles of the Cumberland Settlements*, 205–6, 263.
7. Ibid.
8. Clayton, *History of Davidson County*, 200; Bobby L. Lovett, *The African-American History of Nashville, Tennessee: 1780–1930* (Fayetteville: University of Arkansas Press, 1999), 10.
9. Albigence Waldo Putnam, *History of Middle Tennessee: Or, Life and Times of Gen. James Robertson* (Nashville, TN: Printed for the author, 1859), 642
10. *North-Carolina Star*, April 19, 1933; *New York Evening Post*, April 17, 1833.
11. *Nashville Republican*, January 31, 1835.
12. Clements, *Chronicles of the Cumberland Settlements*, 264.
13. Joseph Thompson Hare, *The Life of the Celebrated Mail Robber and Daring Highwayman Joseph Thompson Hare* (New York: J.B. Perry, 1844), 53.

14. P.R. Hamblin, *United States Criminal History: Being a True Account of the Most Horrid Murders, Piracies, High-way Robberies, etc.* (Fayetteville, AK: Mason & De Puy, 1836), 115
15. H. Faxon, *The Record of Crimes in the United States* (Buffalo, New York: H. Faxon Company, 1834).

Chapter 2

16. James E. Rains, *A Compilation of the General Laws of the City of Nashville Together with the Charters of the City, Granted by the States of North Carolina and Tennessee and a List of the Chief Officers of the Municipal Government of Nashville in Each Year, From 1806–1860* (Nashville, TN: J.O. Griffith and Company Printers, 1860).
17. Rains, *Compilation of the General Laws*, 77.
18. *Nashville Republican Banner*, January 9, 1857.
19. *New York Evening Post*, April 17, 1833; *North Carolina Star*, April 19, 1833.
20. *Nashville Union and American*, October 24, 1873
21. *Nashville American*, June 19, 1897.
22. Herman Justi, *Official History of the Tennessee Centennial Exposition* (Nashville, TN: Press of Brandon Printing Company, 1898).

Chapter 3

23. The outline of these wards is described in federal census records, as well as city charters. Newspapers made reference to the activities on Criddle Street and Cherry Street as taking place on Smoky Row, reinforcing these defined boundaries of the notorious neighborhood.
24. *Republican Banner*, September 30, 1856; July 15, 1857; April 15, 1857.
25. Ibid., August 21, 1856
26. Ibid., March 13, 1857
27. Ibid., January 15, 1858.
28. Ibid., December 11, 1860.
29. Ibid., May 13, 1857.
30. Ibid., July 11, 1857.
31. Ibid., October 23, 1857.
32. Ibid., November 18, 1857.
33. Ibid., January 2, 1859.

34. *Republican Banner Steam Press*, March 25, 1859.
35. *Daily American*, April 21, 1876.
36. *Republican Banner Steam Press*, April 19, 1859.
37. Ibid., February 19, 1857.

Chapter 4

38. Samuel David Gross, *A Manual of Military Surgery* (Philadelphia: J.P. Lippencott & Company, 1862).
39. *Daily Union*, May 15, 1863.
40. Thomas Lowery, *The Stories Soldiers Wouldn't Tell: Sex in the Civil War* (Mechanicsburg, PA: Stackpole Books, 1994), 35.
41. Ibid., 78.
42. Ibid., 89.
43. Ibid., 92.
44. *Nashville Daily Union*, November 20, 1863.

Chapter 5

45. *Nashville Union and American*, January 19, 1871.
46. *Daily American*, November 16, 1877.
47. Jean Lenox and Harry O. Sutton, "I Don't Care" (New York: Jerome H. Remick & Company, 1905).
48. *Republican Banner*, November 10, 1868.
49. *Tennessean*, October 16, 1977.
50. Ibid., January 1, 1973.
51. Ibid., March 11, 1998.
52. *Tennessean*, April 28, 1986.
53. Ibid., January 23, 1998.

Chapter 6

54. *Republican Banner*, January 17, 1879; February 5, 1879; February 19–22, 1879.
55. Ibid., March 28–30, 1879; *Memphis Daily Appeal*, March 29, 1879; *Chicago Daily Tribune*, March 29, 1879.

56. *Wilmington Weekly Star*, April 11, 1879; *Pennsylvania Forest Republican*, April 30, 1879.
57. *Republican Banner*, April 6, 1879.

Chapter 7

58. Mark Dyreson and Jaime Schultz, *American National Pastimes: A History* (Abingdon, UK: Routledge, 2016), 32.
59. *Daily American*, December 27, 1888.
60. James C. Bradford, *The Code of Nashville* (Nashville, TN: A.B. Tavel, 1885), 130.
61. Robert E. Corlew, *Tennessee, A Short History: Updated Through 1989* (Knoxville: University of Tennessee Press, 1990), 252.
62. A quick perusal of Nashville newspapers from the 1890s and 1900s demonstrate the abundant use of racial terms associated with the area known as Black Bottom. Specific references include the *Daily American* of June 15, 1890, and *Baltimore Sun*, May 24, 1902.
63. *Daily American*, July 7, 1888.
64. *Nashville American*, October 11, 1903.
65. Don H. Doyle, *Nashville in the New South 1880–1930* (Knoxville: University of Tennessee Press, 1985), 163.
66. *Nashville American*, June 25, 1908.
67. Ibid., July 12, 1899.
68. Daniel Okrent, *Last Call: The Rise and Fall of Prohibition* (New York: Simon and Schuster, 2010), 8.
69. Corlew, *Tennessee*, 251.
70. *Nashville Banner*, January 2, 1846.
71. Michael Lewis, *The Coming of Southern Prohibition: The Dispensary System and the Battle over Liquor in South Carolina, 1907–1915* (Baton Rouge: Louisiana State University Press, 2016).
72. Doyle, *Nashville in the New South*, 167.
73. Ibid., 168.
74. Ibid., 177.
75. *Nashville Tennessean and Nashville American*, March 11, 1914.
76. Ed Huddleston, *The Bootleg Era* (Nashville, TN: Nashville Banner, 1957), 3.
77. Brian Allison, *Murder and Mayhem in Nashville* (Charleston, SC: The History Press, 2016), 114.

78. Huddleston, *Bootleg Era*, 5.
79. Ibid.

Chapter 8

80. Pau Issac, *Prohibition and Politics: Turbulent Decades in Tennessee, 1885–1920* (Knoxville: University of Tennessee Press, 1965), 107.
81. *Baltimore Sun*, November 10, 1908.
82. *Nashville American*, May 1, 1908.
83. *Tennessean*, September 1, 1908.
84. Ibid., August 31, 1908.
85. Ibid., February 24, 1909.
86. Allison, *Murder and Mayhem*, 99.
87. Ibid., 100–1.
88. *Nashville Tennessean*, September 29, 1912
89. Ibid.
90. Ibid., March 20, 1925.
91. Ibid., June 7, 1925
92. *Kingsport News*, February 20, 1958.

Chapter 9

93. *Nashville Tennessean*, July 28, 1929.
94. Ibid., December 19, 1926; *Nashville Banner*, December 20, 1926.
95. *Nashville Tennessean*, May 10, 1931.
96. Ibid., July 3, 1931.
97. Ibid., July 4, 1931; *Nashville Banner*, July 4, 1931.
98. *Nashville Tennessean*, December 15–17, 1931.
99. Ibid., December 20, 1931.

Epilogue

100. William U. Eiland, *Nashville's Mother Church: The History of Ryman Auditorium* (Nashville, TN: Grand Ole Opry, 2014); Theodore M. Smith, *Sermons by Rev. Sam. P. Jones* (Philadelphia: Scammell & Company, 1887).
101. *Nashville American*, June 10, 1901.

About the Author

Elizabeth K. Goetsch grew up in the military, never spending more than a few years in one location before moving. She came to middle Tennessee for graduate school and has now lived in the area for nearly ten years. After serving as a park ranger, she left the National Park Service and began working for Echoes of Nashville Walking Tours. Uncovering Nashville's unique and complex history became a side effect of working for the walking tour company. Elizabeth received her bachelor's degree in history from New Mexico State University and her master's degree focused in public history from Middle Tennessee State University.

Visit us at
www.historypress.net
...
This title is also available as an e-book